PAINTING GARDENS

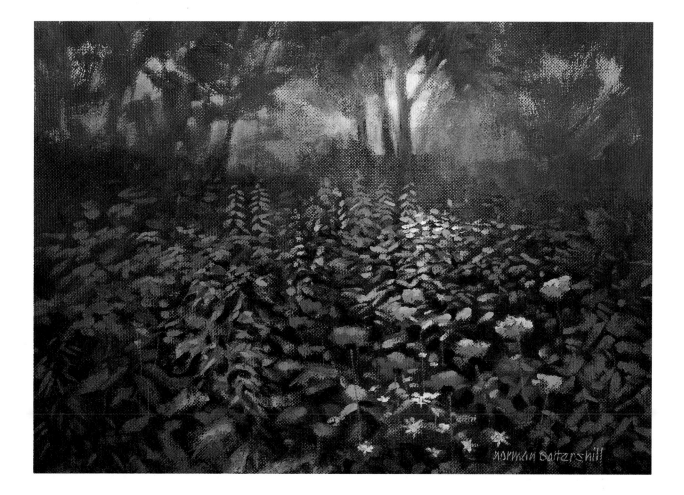

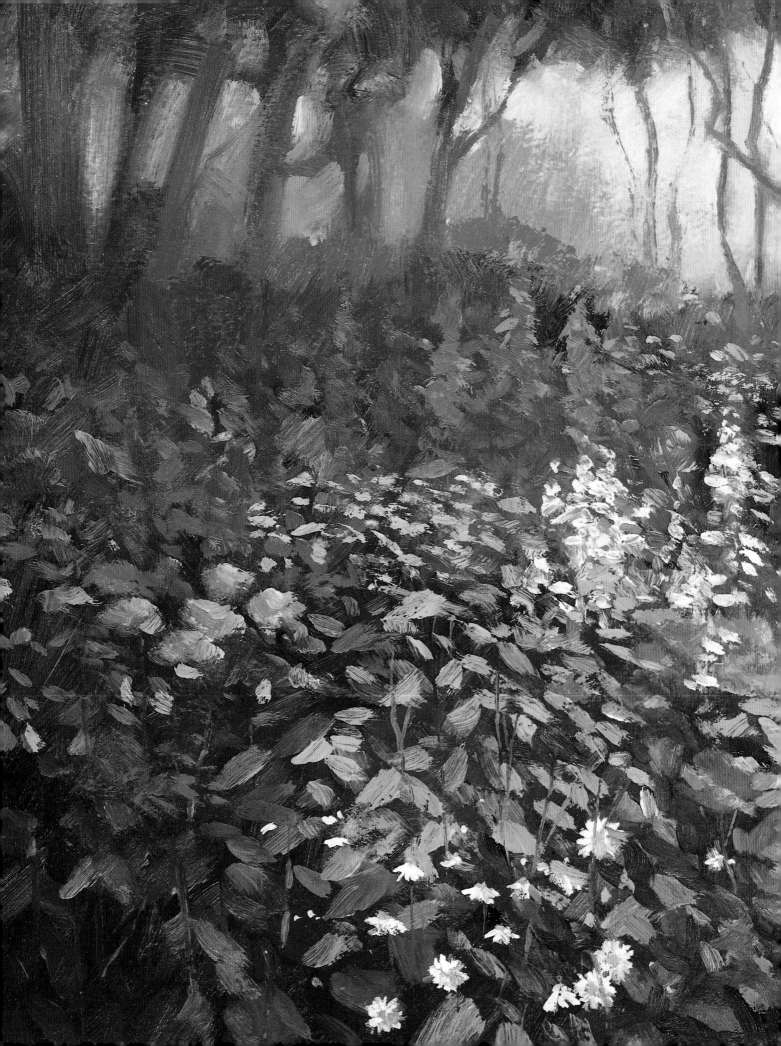

PAINTING GARDENS

Norman Battershill

RBA ROI PS

B. T. Batsford Ltd, London

O happy Garden! Whose seclusion deep
Hath been so friendly to industrious hour;
And to soft slumbers, that did gently steep
Our spirits, carrying with them dreams of flowers,
And wild notes warbled among the leafy bowers.

From *A Farewell*
by William Wordsworth
(1770–1850)

ACKNOWLEDGEMENTS

I would like to thank the following: my editor, Rosalind Dace, for all her enthusiasm and assistance in producing this book; Miriam White for her faultless typing; and Michael McEnnerney L.B.I.P.P. for photographing my work, supplying colour transparencies, and taking the black-and-white portrait photographs.

My thanks also go to those who have kindly supplied me with reference material and information, in particular the Royal Botanic Gardens, Kew, Richmond, Surrey, England; the Royal Botanic Garden, Edinburgh, Scotland; the University of Oxford Botanic Garden, England; Savill Garden and Valley Garden, Windsor Great Park, England; Stourhead Garden, Wiltshire, England; and the Garden Club of America, 598 Madison Avenue, New York, NY10022.

My thanks and appreciation are also due to the many private owners who open their delightful gardens for the pleasure of visitors.

First published 1994

© Norman Battershill 1994

Typeset by Latimer Trend & Co. Ltd, Plymouth, UK

and printed in Hong Kong

Published by
B. T. Batsford Ltd
4 Fitzhardinge Street
London W1H 0AH

British Library Cataloguing-in-Publication Data.
A catalogue record for this book is available from the British Library.

ISBN 0 7134 6932 3

CONTENTS

FOREWORD

I feel privileged to have a place in Norman Battershill's new book and am very happy with the subject of painting gardens. Perhaps Norman remembers my garden in the Weald of Kent – which gets so little of my time, I hastily add.

Flowers are also my great joy, as the staff of *Leisure Painter* will attest when they all too frequently need to talk me out of putting yet another flower composition on the front cover of the magazine. An idea close to my heart (if I ever have the time) is to start the first flower-painting society, with which I hope my good friend Norman Battershill will agree to be involved.

So it is with pleasure that I read through the manuscript of Norman's *Painting Gardens* in February 1993, on a dull day which is now enhanced by the author's strong and positive colour. The book should be of interest to most painters, whether they wish to paint a still life in the corner of a greenhouse, the cornucopia of a garden centre or the grand vistas of a formal garden. Norman's advice on capturing the delicacy of flowers or the perspective of hard-edged glasshouses will be invaluable.

It is interesting to note that the author worked as a designer early in his career and was elected a Fellow of the Society of Industrial Artists and Designers. Norman's strong sense of design is obvious in his work, and also follows through to his use and choice of colour. Acceptance by his peers in the fine-arts sphere has followed, and he is a member of such distinguished societies as the Royal Society of British Artists, the Royal Institute of Oil Painters and the Pastel Society.

The reader will not be disappointed with the variety of subject matter in this book, which vibrates with firm brushstrokes and often scintillating colour. Those who paint in one medium only are also given a bonus of information from Norman's wide range of skills with different media. Even the lovely effects of charcoal are represented – a special medium, I always feel, which is so neglected at the moment.

Anyone who reads this book must feel better informed and happy to specialize in a painting subject which offers so much scope for individual interpretation. It is a good read in the winter and a useful back-up to summer painting trips, when we are all looking for something meaningful to paint. Even the housebound can benefit – and not only because most of us have a dustbin (see the painting on page 19). As the author says: 'Transformed by the effect of sunlight and shadow, this humble, everyday object makes an interesting composition.'

What marvellous subjects for expression in paint; the many, many people who enjoy Norman Battershill's work will appreciate this book and extract much to awaken new thoughts for their own painting.

Irene Briers
Publisher of Leisure Painter
and The Artist *magazines*
February 1993

INTRODUCTION

*P*ainting flowers in a garden must surely be one of the most delightful subjects an artist could possibly wish for. While research-ing material for this book, however, I realized that there are other exciting aspects which would also be of related interest. The scope available to the artist for painting a wide variety of gardens is unlimited.

The National Gardens Scheme, for example, publishes a list of more than 2,600 private gardens open to the public in England and Wales (see page 126). The National Trust public-ation (see also page 126) contains a list of over a hundred gardens in its care. In Ireland and Scotland many small and major gardens are also open to the public.

This impressive list does not include innumerable garden centres, royal gardens, water gardens, botanical gardens and other types of specialist gardens. Any one of these has exciting possibilities, but explore your own garden first. You will discover a surprising variety of subjects there, and you will be able to concentrate more and work without hindrance. The privacy and seclusion may also give you inspiration to paint a larger and more ambitious painting, which would not be practical in a public place.

The ability to produce a successful garden painting in the studio is the result of consis-tently painting outdoors. Being aware of the effects of weather and changing seasons is also a vital part of your development as an artist.

The vegetable garden must not be over-looked, for here can be found a rich variety of subjects. Cloches, bean poles, cold frames and garden implements add to the many possibilities of a vegetable patch.

An aspect of water in a garden, however small, creates a magical dimension of reflected sky, light and movement. A subject which includes water always has added interest and should be painted well.

Glasshouse interiors have a wonderful effect of diffused silver light. Even the smallest green-house has this unique atmospheric quality of

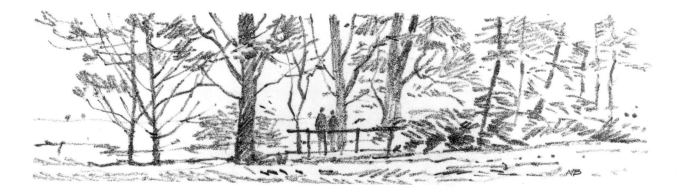

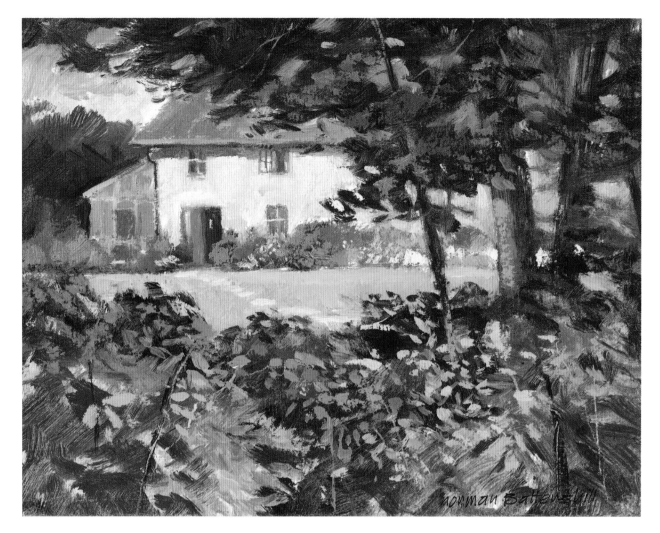

soft light. In spring and summer the commercial glasshouses at garden centres are massed with the beautiful colours of bedding plants, providing subjects with many possibilities for the flower painter.

Trees are an essential part of the landscape and gardens. They add life and a structural dimension to even the most humble of gardens. Painting trees well should be the aim of all artists, and is particularly applicable to our subject of gardens. Successful flower painting is more likely to be achieved by understanding the form and structure of flowers, and drawing is the key to achieving this aim. Colour harmony is also an essential element of success.

I have structured this book into specific chapters which include all these subjects, as well as many more for your added interest. Whatever medium you paint in, you will find examples illustrated in the following pages. Writing and illustrating this book has given me the greatest pleasure. Exploring the possibilities of related subjects has widened my experience and added to the joy of painting. I am sure that you will also experience similar pleasure in painting aspects of gardens.

BIOGRAPHY

Norman Battershill is a member of the Royal Society of British Artists, the Royal Institute of Oil Painters, and the Pastel Society. Before deciding to paint full-time he had a very successful career as a freelance designer with a studio in Knightsbridge, London. In recognition of his design work he earned the distinction of being elected a Fellow of the Society of Industrial Artists and Designers. During this time he also painted, illustrated books, received commissions for murals, and regularly exhibited at the London art galleries.

Eventually, he decided to paint full-time and moved his studio from Knightsbridge to Sussex. Very soon afterwards he was appointed

as a demonstrator for Winsor & Newton, travelling to art clubs throughout the British Isles and the Channel Islands. At this time he was asked to feature in the Winsor & Newton film, *Painting with Acrylics*. For several years he also tutored the Pitman Correspondence Course in pastel.

Norman Battershill has been a regular contributor of instructional articles to *Leisure Painter* and *The Artist* magazines for many years. His popular painting courses are always fully booked in advance. Some of his commissions have included paintings for CIBA-GEIGY, Ricardo Engineering, Beecham Pharmaceuticals, British Gas Southern and the Post Office. He has also produced drawings for Post Office stamp books and *Newsweek* International. His paintings have been featured on Southern Television.

In 1987 Norman Battershill received the Royal Institute of Oil Painters Stanley Grimm Award, presented by H.R.H. the Duchess of York. He is the author of a number of art-instruction books, and writes and paints from his home in Dorset.

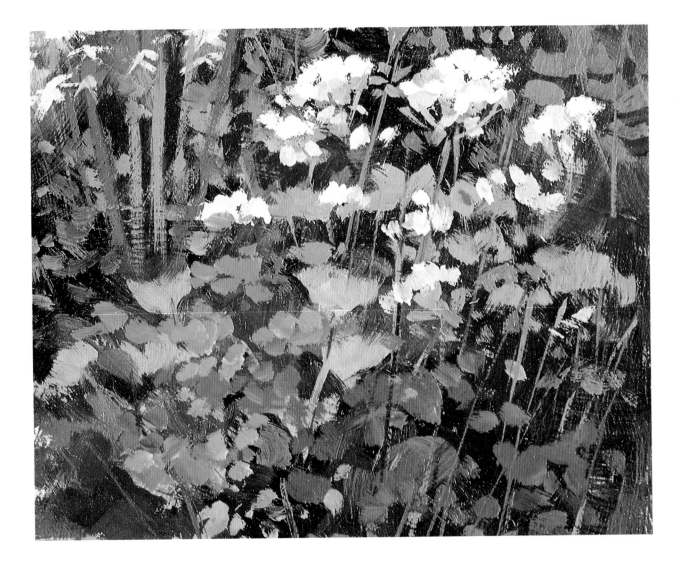

MATERIALS

Whatever medium you work in, you will find in this book a great variety of subjects illustrated in oil, acrylic, gouache, watercolour and pastel. I work in all media, and enjoy being able to change readily from one to another; this ability has greatly increased my pleasure in painting and has widened the scope of my self-expression. No painting book would be complete without some aspects of drawing, and in the following pages you will also find sketches in charcoal, carbon pencil, crayon and coloured pencils.

If you have not yet tried working in another medium, the various examples in this book may encourage you to do so. Each medium has its own characteristics of handling, and making it work for you takes time and patience. By giving time to trying other media, however, you may find one more suited to your style.

My method of working in the various media will be of interest to you, so I have included descriptive notes with each illustration. You will find useful hints on painting techniques, colour mixing, using a limited palette, painting supports, primers for oil and acrylic, and also some drawing techniques.

There are a number of comprehensive books on methods and materials already on the market, so I have not taken up valuable space by repeating here what has been written elsewhere. Instead, I have made this section informative by basing it on my personal experience of handling the different media. I hardly need add the reminder that your choice of materials should, if possible, be nothing less than artist's quality.

PENCIL

For outdoor sketching I prefer soft pencils. As well as charcoal pencil, I also use a conté pencil and 2B, 4B, or 6B lead pencils. The texture of a pencil mark is determined both by the surface of the paper, and by the pressure that is put on the pencil.

If my choice were restricted to just one type of pencil, I would choose charcoal or conté pencil, as each makes a dense, matt-black mark. I do not fix my sketchbook pencil drawings, unless they are in charcoal or conté pencil which both smudge easily.

I seldom use crayons, but have included an example on page 106. The range of beautiful colours available is extensive, and particularly suited to our subject of gardens. I must find the time to use them more often!

Pencil on cartridge paper, 50 × 175 mm (2 × 7 in.)

CHARCOAL

The humble charred willow twig is the oldest and most natural of all the drawing media used by artists today. Charcoal is unequalled for its versatility and immediacy. Capable of a variety of exciting marks and broad masses of tone, it is undoubtedly my favourite drawing medium.

Charcoal on Bockingford watercolour paper, 121 × 152 mm (4¾ × 6 in.)

Combining watercolour with charcoal has a unique charm all of its own. Charcoal pencils do not have the versatility of sticks of natural charcoal, but I like the pencils for outdoor sketching. Charcoal smudges easily, so I make sure to fix a drawing with aerosol fixative (ozone-friendly, of course!) as soon as it is finished.

Using soft white pastel and charcoal on neutral-tinted pastel paper is a technique that I often use for drawing. The tinted paper provides a middle tone, charcoal the darker tones and the white pastel gives highlights. This combination is ideal for quick tonal sketches. Apart from pastel, fleeting moments of light and shade can be captured faster with charcoal than any other drawing medium. Lifting out from a charcoal drawing with a putty eraser is an exciting technique.

Provided that it has a slight texture, smooth or medium-surface drawing paper is suitable for charcoal pencil or a charcoal stick. It is well worth experimenting with different papers, especially tinted pastel paper and cartridge paper.

PASTEL

Most artists at some time or other become dispirited with their work. When this unfortunate lapse happens to me, I make a change of

medium and switch to soft-chalk pastel. The bright, instant colours are an immediate tonic to the jaded spirit.

There is a misconception that pastel is inferior to the traditional media of oil and watercolour, but whereas watercolours may fade and oils eventually darken, pastel paintings are permanently lasting. The masterly pastels of Degas (1834–1917), seen in Europe's national galleries, retain their fresh bloom of colour to this day.

Soft-chalk pastel is an ideal medium for flower subjects. From the range of over two hundred shades and tints available, there are colours to suit every garden subject. There are several brands of soft-chalk pastels. My personal choice is Unison, distributed by Osborne and Butler, as the chunky sticks encourage a painterly approach.

Some manufacturers supply sets of pastels especially selected for flower painting. By supplementing a basic set with further colours bought singly, an impressive range of beautiful colours may be built up gradually. I now have over four hundred pieces of assorted colours. Included in this range are muted tints and shades, which I use for landscape painting. These neutral tones are also ideal for creating backgrounds to flower studies.

The technique of fixing each layer of pastel with fixative creates new surfaces on which to work without disturbing the layers beneath, but colours become slightly darker because the pastel absorbs the spray. To keep my pastel painting fresh, therefore, I try to avoid using fixative as far as possible. Soft-chalk pastel is easily blended by smudging with a finger, a paper stump, chamois leather or kitchen tissue, but bear in mind that too much softening will weaken a painting.

Most of my pastel paintings are on neutral-tinted pastel papers with a medium surface. There are other grounds that can be used for pastel, however, including watercolour paper, cartridge paper, fine sandpaper and mounting boards. You should bear in mind that conservation framing is essential to protect a work of art on paper.

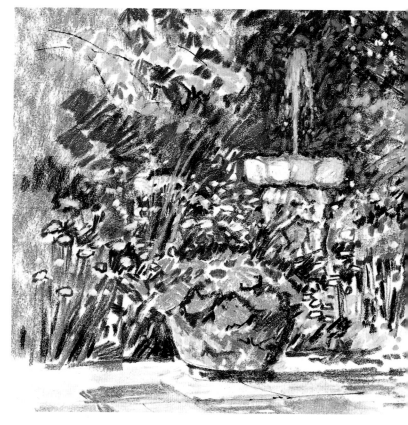

Pastel on smooth white card, 152 × 152 mm (6 × 6 in.)

ACRYLIC

I have been an enthusiast of acrylic for many years, and as a demonstrator for Winsor & Newton I had the pleasure of introducing this versatile medium to a great number of art societies.

An advantage of acrylic is that it is diluted with water. For this reason it dries very quickly, so that what may seem to be a disadvantage can prove to be an asset. Progressive stages of painting soon dry and may be varnished in twenty-four hours if the paint is not too thick. Acrylic is waterproof when dry, so glazing techniques may be applied without the colour underneath lifting. This makes acrylic

Acrylic on smooth white card, 159 × 216 mm
(6¼ × 8½ in.)

ideal for flower painting and the glazing of transparent colour. Another advantage of acrylic is that it can be used in the manner of oil or watercolour. The varnishes for oil paintings are also suitable for acrylic; I prefer Winsor & Newton retouching varnish.

To prevent acrylic drying hard on brushes it is essential to wash them thoroughly. When I am painting, I wash the brush and lay it flat while it is still wet. This ensures that the brush stays moist and cannot dry out. I use the same types of brushes for acrylic as I do for oil – the long, flat hog brushes hold a lot of paint and seem to suit my style.

Acrylic adheres firmly to a porous surface, so it is not a good idea to use a wooden palette. I find the tear-off paper palettes the most convenient, but you may prefer a melamine palette.

I normally use the smooth side of acrylic gesso-primed hardboard (Masonite) for my acrylic paintings. Primed watercolour paper of not less than 140 lb (300 gsm) and acrylic-

primed canvas are other supports that I like for acrylic work.

The range of acrylic colours available is extensive. For flower painting there are some beautiful fresh colours to add to your palette. I do not find it necessary to use an acrylic medium or acrylic varnish, except for glazing, but this is a personal choice and you may find them useful.

OIL

The rich and expressive quality of oil is admirably suited to painting flowers and gardens. As with acrylic, it is tempting to set out the palette with an array of wonderful colours, but I always begin with no more than three colours – cadmium red, French ultramarine and cadmium yellow – as well as titanium white. Quite often this combination of primaries is adequate for painting flowers. As an alternative I may start with another primary range: cobalt blue, alizarin crimson and cadmium lemon. As the painting progresses I add further colours to my palette. Some oil colours are extremely expensive so check the price before being tempted to buy. If you paint flowers a great deal, the investment will be justified.

Most of my oil paintings are on acrylic gesso-primed hardboard (Masonite), or on canvas laid panels. I also like to paint in oil on watercolour paper. To ensure maximum durability, I only use high-quality, heavy paper. To protect the paper from the oxidative effect of the drying oil, I ensure that it is well primed with acrylic gesso primer or sizing. Suitably prepared paper is ideal for outdoor oil sketches. A dozen pieces of paper weigh much less than the equivalent quantity of hardboard (Masonite), making them much easier to carry.

I prefer not to use any medium when painting in oil. If I want the painting to dry fairly quickly, I add Winsor & Newton Liquin to the colours. For painting outdoors, my French box easel has given me constant service for more

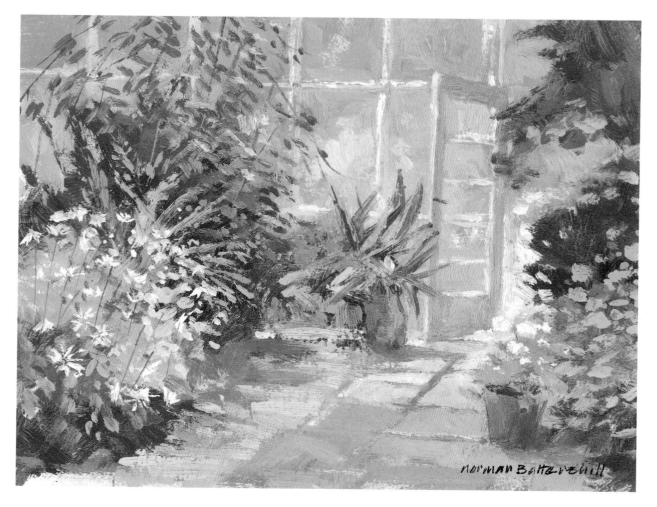

Oil on Bockingford watercolour paper, 165 × 217 mm
(6½ × 8½ in.)

than thirty years. The 254 × 203 mm (10 × 8 in.) pochade has also served me well. In my studio I have a radial easel and couple of big old-fashioned adjustable easels, which are also very useful.

WATERCOLOUR

I paint in oil and acrylic most of the time, and work from dark to light in the traditional technique. Reversing the method for water-colour is a slower process which I find very frustrating, but a clean, fresh watercolour painting has a unique quality that is worth striving for, so I try to curb my impatience and persevere. I must confess that it does not always work for me as I would like, but that is the challenge of watercolour.

My preference in paints is for Winsor & Newton tube colours. Depending on the sub-ject, I normally limit these to a few and add others as required. My basic list comprises the following: French ultramarine, Payne's gray, cadmium lemon, cadmium red, alizarin crimson and cobalt blue. In the studio I use a large plastic watercolour palette measuring 340 × 240 mm (13½ × 9½ in.).

Watercolour on smooth white card, 83 × 121 mm (3¼ × 4¾ in.)

Of several watercolour paintboxes that I have, my favourite is a treasured old Roberson enamel folding box, which I often use for painting outdoors. Pocket watercolour boxes are particularly handy for colour notes or for small sketches outdoors. The best of all is the ingenious Winsor & Newton Cotman Field Box. It comes complete with twelve half-pans, mixing palette, sponge, water container, water bottle and a sable brush. Together with a small sketchbook, this handy lightweight box fits easily into a pocket.

Watercolour paper

I use most traditional watercolour papers and boards, as well as smooth (hot-pressed) thin card and grey-tinted pastel paper. The brilliant white hot-pressed card gives a lovely clarity and freshness to watercolour, which I like. As it is absorbent, however, the usual techniques of watercolour are sometimes limited. I have used smooth white card for almost all the water-colours in this book.

GOUACHE

Gouache is pigment mixed with Chinese white to give it opacity. Poster colour is similar, but is not of the same artist's quality. Although gouache is well suited to flower painting, it does not seem to have the popularity it deserves. I only paint in gouache occasionally, but I enjoy using this versatile and expressive medium. Its appeal for me is that I can paint using the same method as I do for oil and acrylic, i.e., from dark to light. Gouache can be used very effectively on tinted paper.

Gouache has a tendency to dry lighter, so this change in tone values has to be allowed for. Adding white to watercolour creates the effect of gouache, but too much white may cause flaking and chalkiness.

Some notable artists who used body colour (gouache) to great effect are William Turner, Henry Hunt, Peter De Wint, Thomas Girtin and Hercules Brabazon Brabazon.

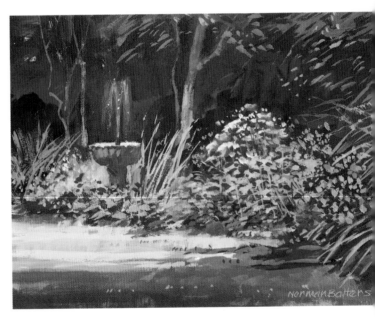

Gouache on smooth white card, 133 × 184 mm (5¼ × 7¼ in.)

DISCOVERING SUBJECTS

However uninteresting a garden appears to be, there is always a subject for painting. We may look at our garden dozens of times a day without really taking too much notice of what is there, as familiarity often has a tendency to block perception. The dustbin painting illustrated on page 19 is an example.

When I lived in suburban London many years ago, I had a ground-floor flat in Wimbledon with a depressing backyard. The only feature of this barren patch was the dustbin. Although I saw it every day I had no inclination to paint it, until a fleeting moment of sunlight revealed the wonderful contrast of light and shade. The humble dustbin suddenly came to life. The shapely leaves of lily-of-the-valley and the discarded clay flowerpot completed a fascinating composition. Racing against the sun changing position, I was fortunate enough to finish the oil painting in one session. While I was painting a neighbour leaned over the fence and exclaimed, 'My brother's good at painting – he's just finished our front door.' I shall always remember my dustbin as a lesson in learning to find hidden subjects in mundane surroundings.

A friend of mine has a town house with no garden except for a tiny first-floor concrete balcony overlooking a municipal car-park. The balcony has been transformed into a cool oasis of greenery, complete with the gentle sound of water trickling from a re-circulating wall fountain. Even in this microscopic and restricted area there is enough exciting material for a whole series of paintings, which I propose to start at a later date. The problem will be where to stand my easel and find enough room to paint.

The best time to explore your own garden is when it is sunny. The contrast of light and shadow is sure to reveal painting potential in the most ordinary subject, as it did with my dustbin. Quite often a close-up view has more interest and impact than a view from further back, and a viewfinder isolates areas into potential subjects which are not immediately apparent. Instead of painting a picture of the garden shed, for example, why not just use the padlock and hasp as a subject? If they are rusted and the door is weather-beaten, so much the better. The viewfinder that I use is made from dark grey card. The dark tone helps to isolate subjects better than white.

A viewpoint from the end of the garden looking toward the back of a house has many possibilities. An elegant Edwardian house in

south London where I lived had a beautiful long and narrow garden. One of the paintings that I produced there measures 1·82 m × 914 mm (6 × 3 ft), and the tall, narrow, vertical format suited the proportion of the subject perfectly. I chose a viewpoint looking from the end of the garden back toward the house through the laurel bushes and trees. The beautiful orange colour of Chinese lanterns growing through the laurel made exciting touches of brilliance against the deep green leaves.

Some of my earliest commissions included painting houses in a garden setting. The tedium of counting windows, glazing bars and chimneypots was always compensated by the pleasure of painting the garden.

FOREIGN GARDENS

Travelling abroad considerably extends the possibilities of painting gardens. Some hotels and villas have wonderful colourful gardens in exotic settings, and the opportunity to paint them should not be missed. I stayed in a Lanzarote villa which had enormous geranium bushes growing through volcanic ash. The brilliance of the flowers against sunlit white walls and a cobalt blue sky inspired a series of bright paintings.

Public gardens abroad are well worth visiting. I once discovered in the very heart of Paris a tiny oasis of a public garden. As I sat sketching, my only companions were house sparrows and a geriatric balding grey parrot perched in a nearby tree. The atmosphere in this small garden was so magical that I became totally oblivious to the tumult of traffic surrounding it. Back home in the studio, I made several paintings from those sketches.

Rodin's garden is another place in which I spent some time. At any moment I expected the great sculptor to come along the path. The atmosphere in this garden is quite extraordinary.

The panoramic garden of Versailles is aptly named the greatest garden in the world. The geometric layout of parterres and lawns makes wonderful abstract patterns. During my visit there I did some pencil drawings of the parterres with the magnificent chateau in the background.

I have not yet had the chance of visiting America, but if I were in the region of the southern United States I would certainly go to see the magnificent gardens of Charleston. Working from a reference, I have painted my impression of the colourful Cypress Gardens there (see pages 86–7).

There are so many opportunities for painting a great variety of garden subjects in countless locations. The exciting part is discovering them.

(Opposite) DUSTBIN.
Oil on canvas panel, reproduced actual size

The dustbin is one of my early oil paintings, and I have included it as an example of the hidden potential in the most mundane of subjects. Transformed by the effect of sunlight and shadow, this humble, everyday object makes an interesting composition.

The colours that I used were Prussian blue, light red, cadmium yellow, yellow ochre and titanium white.

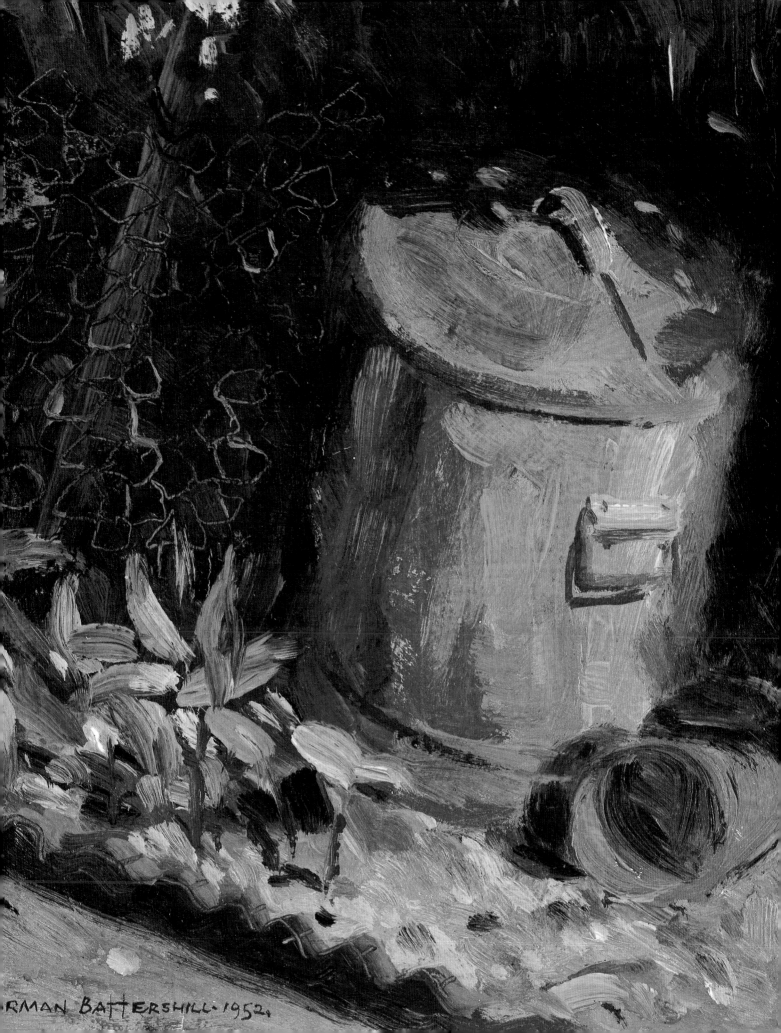

RMAN BATTERSHILL · 1952.

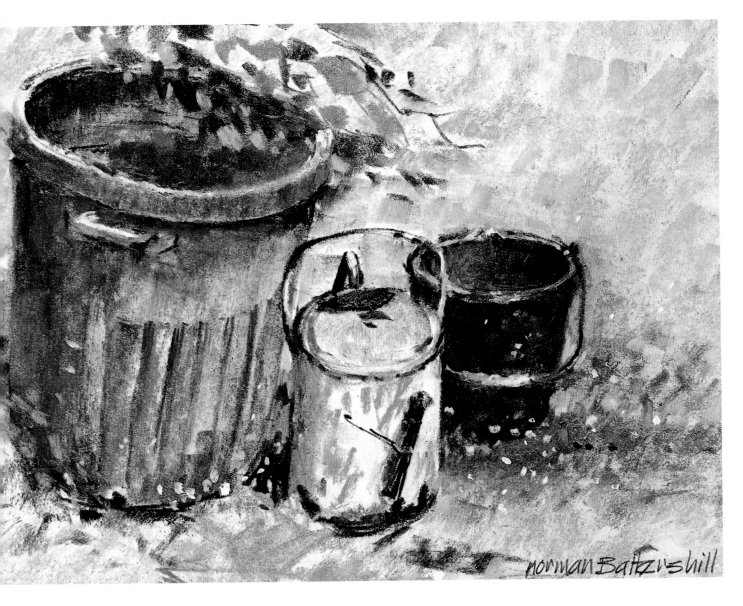

A CORNER OF THE GARDEN.
Pastel on smooth white card,
178 × 235 mm (7 × 9¼ in.)

Another dustbin painting – but very much more recent than the one on the previous page. The group forms a tight but interesting composition of angles and curves which counterbalance each other. With a subject like this, it is often necessary to have an anchor to add strong contrast.

The dark tone of the bucket stabilizes the composition and gives it strength.

Before I began painting, I looked at a number of alternative viewpoints. They all had interest, but I liked the way that this arrangement leads into the picture. I painted in pastel direct, without any preliminary drawing, as I wished to make it a spontaneous impression. An application of aerosol fixative on the smooth card gave a very slight, pleasing texture, enough for the pastel to 'bite'.

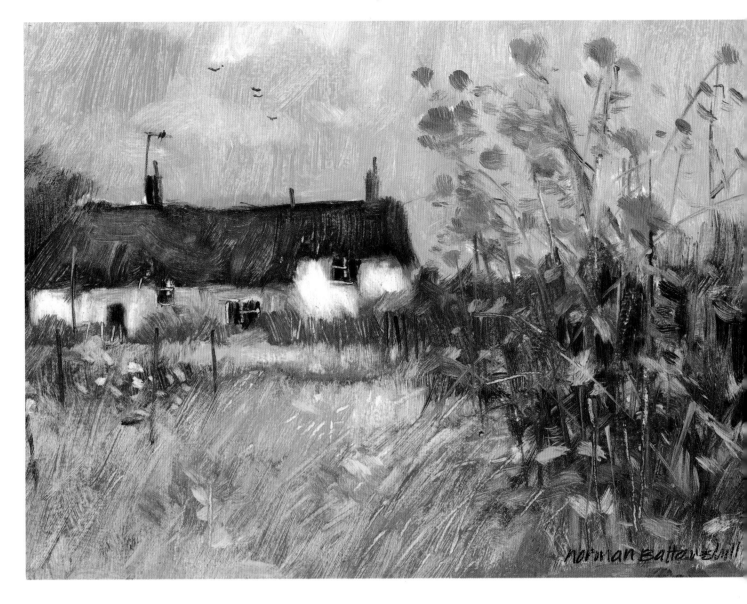

NEGLECTED GARDEN.
Oil on acrylic-primed white card,
178 × 235 mm (7 × 9¼ in.)

This overgrown garden and derelict Dorset thatched cottage have the potential for a whole series of paintings. I chose this viewpoint because it is simple and leads into the picture. I also liked the pattern of windows and door.

What must once have been a flourishing vegetable garden is overgrown with coarse grass and weeds, but the delicately scented roses still flower and add colour to the garden so long abandoned, but no doubt remembered with affection. I can imagine how it used to be, with rows of well-tended vegetables, a trim lawn and colourful washing drying in a fresh breeze.

I thinned the paint for this oil sketch with Winsor & Newton Liquin medium; the translucency seemed to suit the mood of the painting. The colours that I used were French ultramarine, cadmium red, lemon yellow, burnt sienna and titanium white.

POTTING SHED.
Watercolour, charcoal and pastel on smooth white card,
134 × 171 mm (5¼ × 6¾ in.)

Soft light filtering through the dusty windows of a garden–shed interior gave me the idea for this sketch. I particularly like the crumpled shape of the fertilizer sack, and the way in which the light emphasized the folds.

I simplified the subject to areas of big shapes which form the main interest. There were a number of other viewpoints here which could have the possibility of further interesting subjects, although poor light is unfortunately a problem.

My sketch started out as a charcoal drawing. I then fixed it and added touches of watercolour and pastel. The combination of mixed media is extremely versatile and a quick way of producing a sketch. I added the lettering on the sack with a carbon pencil.

(Right) CHASSIS.
Oil on canvas, 610 × 762 mm (24 × 30 in.)

I could not believe my luck when I discovered this old car chassis in a garden orchard, concealed under rolls of chicken wire. What a wonderful subject. The day was very bright, but cloudy, so I had to cope with the problem of constantly changing light filtering through the leaves of the apple trees.

I established all the darkest tones first with purple, mixed from French ultramarine and cadmium red. I diluted the colour with turpentine, which dried quickly, enabling me to

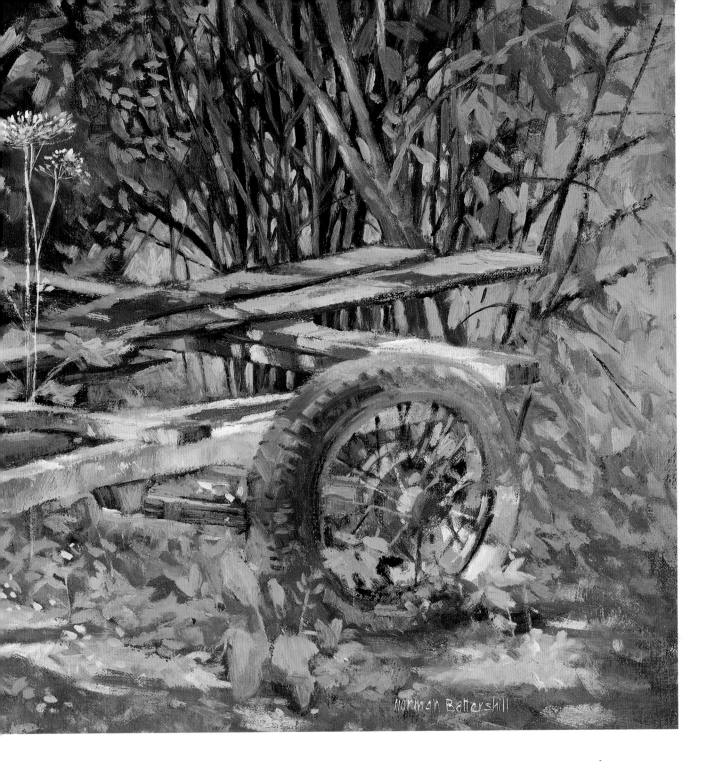

Norman Battershill

establish the effect of sunlight rapidly.

The feature of this painting is really the car wheel, and that was the part that caused me the most trouble because of the fluctuating light. It was tempting to overstate the sunlight, but I was concerned

with an overall harmony of middle-tone values.

The acute angle of the boards on the chassis takes interest toward the side of the painting, but the vertical of the cow parsley arrests this movement and balances the composition. I repeated the

rusty colour of the wheel rim elsewhere in the painting to give unity.

I painted this oil in two afternoon sessions. My colours were French ultramarine, cadmium red, cadmium yellow, light red, lemon yellow and titanium white.

SPARROWS AND SUNLIGHT.
*Watercolour on smooth white card,
reproduced actual size*

The late-afternoon sun transformed this ordinary subject into fascinating contrasts of light and dark. Marigolds in the foreground emphasize the effect of sunlight on the garden path. The lane beyond the gate is devoid of detail, but suggests sunlit shrubbery. I was rather concerned about the pointed shapes of the gate railings, but the overhanging shrubbery takes away some of the emphasis. It is important to be aware of small, obtrusive shapes like this, as they can easily dominate a subject and spoil a composition.

Although I added brick patterns to the path, it still looked too flat and empty. To counterbalance this I added some sparrows; if you cover them up with your finger you will see how important they are to the composition. The forceful angle of the path leads straight into the picture, but I have counterbalanced this by the strong horizontal shadow at the bottom of the gate.

I established all the light areas first, and then gradually built up the tones to the final darks. I used a middle tone for the overhanging shrubbery, with a dark tone to suggest broad-leafed foliage. The watercolours that I used were French ultramarine, lemon yellow, cadmium yellow, burnt sienna, cadmium red and alizarin crimson.

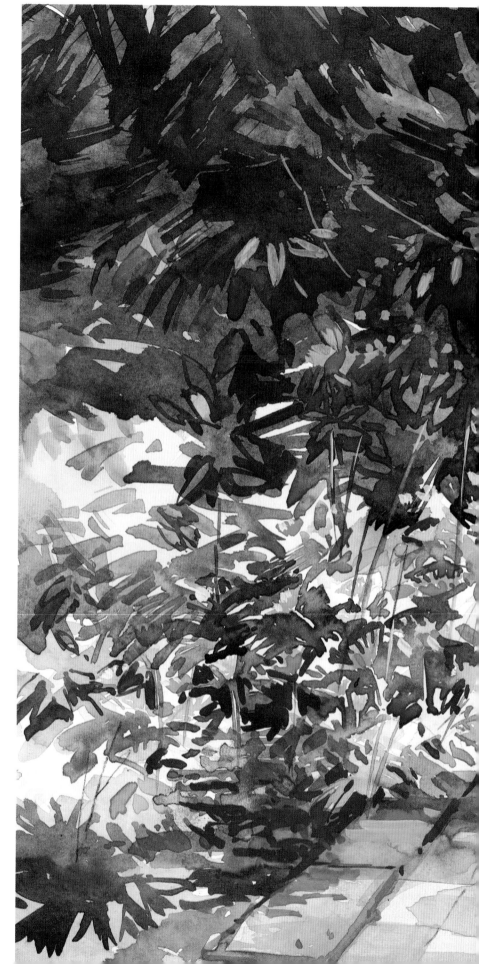

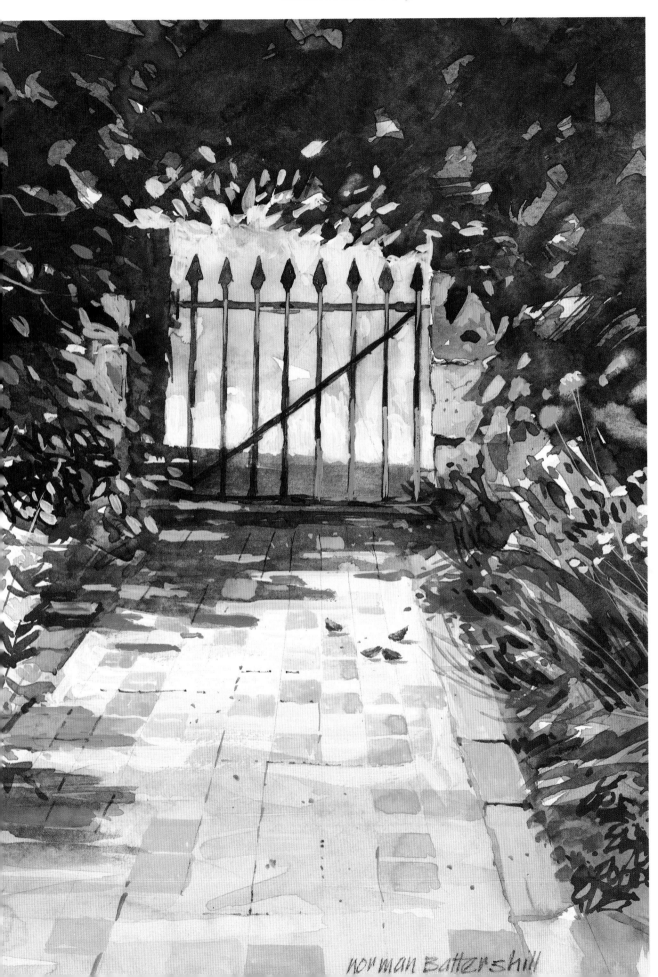

norman Battershill

TEXTURES.
*Acrylic on paper, 102 × 305 mm
(4 × 12 in.)*

This small painting is about shadow and textures. I was attracted to the contrast of the gravel path with the smooth surface of the stone steps. I also liked the rich shadow underneath the slabs. My subject was in full sun and much higher in tone value, but by lowering the overall tone I was able to capture the richness of the shadows and the effect of sunlight.

Although the red flowers are important to the painting, I took care not to emphasize the colour too much. I added some grasses to break up the line of shadow in the background. The acrylic colours that I used were French ultramarine, raw sienna, cadmium red, cadmium yellow medium, burnt sienna and titanium white.

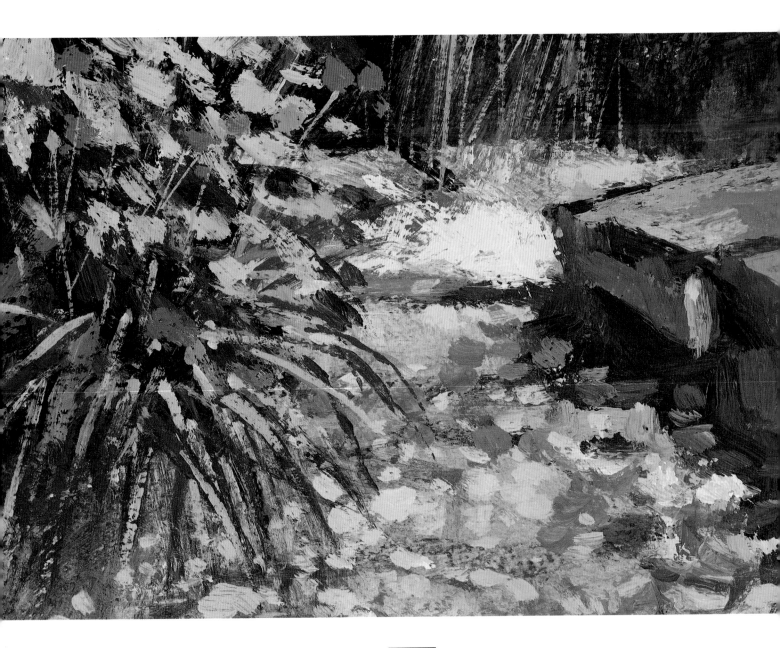

SUMMER SKETCH.
Charcoal stick on white card,
178 × 229 mm (7 × 9 in.)

Charcoal is such a beautiful and expressive medium, and ideally suited to the rapid spontaneous sketch shown below. It is the simplest of subjects, but may well contain enough material for a painting. Wandering around the garden just making a few quick sketches like this is very satisfying. All you need is a stick of willow charcoal, paper, a putty eraser and fixative.

This sketch is on smooth white card. The surface is ideal for smudging and lifting out with a putty eraser. I left the white of the card showing to suggest sunlight. The tree, and the shrubbery at its base, are examples of the lifting-out technique. You can smudge charcoal with a tissue, but on this smooth card the tissue

would have lifted off more charcoal than I wished, so I smudged with my fingers instead. I simplified my subject into the essentials, rather than putting in all the confusing bits of detail that I could see.

A sketch does not necessarily have to be a subject for painting. Sometimes I sketch just for the sheer pleasure of it, and at the same time I am improving my powers of observation. As a project, make a series of garden sketches of the same subject, each one becoming more simplified than the last.

EARLY SNOW IN DORSET.
Soft-chalk pastel on mid-grey
Fabriano paper, 222 × 269 mm
(8¾ × 10½ in.)

Painting in the snow is an experience not to be missed. The stillness and transformation of a familiar view create a wonderful sense of atmosphere. An early fall of snow gave me the opportunity for this outdoor pastel sketch. It was bitterly cold, but as I was standing at my easel I could move around to restore my circulation now and again.

There was no smoke coming from the chimney when I was painting, but I added it to give some movement. The last roses of summer gave me the opportunity to add warm spots of colour. Remember that painting in a garden need not be confined just to summer days; winter can be equally pleasurable.

It is sometimes much more practical to paint a modest-sized picture than a large-scale one. A small painting can be just as complete in itself as a more ambitious painting. I used only a few pastels for this painting on mid-grey Fabriano paper: silver white, burnt umber, light red, French ultramarine, mauve and black. I left parts of the paper showing in the final stages.

PAINTING FLOWERS

Understanding the structure and form of flowers is the key to successful flower painting, and drawing them is the only way to acquire this knowledge. Holding a flower lightly in your hand while you draw also combines the pleasure of touch.

For most of my studies I prefer a 2B pencil and cartridge (drawing) paper. Drawing the detail of flowers much larger than life-size is easier and better than a small, cramped drawing. Rhythm, pattern and form are the key factors to look for when drawing and painting flowers.

Studying a small part or a section of a flower under a powerful magnifying glass reveals a most secret and beautiful world of natural structure. The section through a dried poppy-head is a revelation. I have included some sketches on page 32 to illustrate the extraordinary beauty and function of nature's design. Many other flowerheads, such as the teazel and dandelion, reveal an intriguing hidden world of delight. For detailed studio drawings of flowers, my free-standing adjustable magnifying glass is ideal. I also have a small but powerful jeweller's magnifying glass, and carry it with me when I go out painting or drawing.

Painting flowers growing in a garden presents similar problems to those which try the patience of landscape painters. The changing effect of light and shadow and other factors add to the problems involved, but any frustration or discomfort is amply compensated by the exhilarating pleasure of painting outdoors. When the effect of sunlight and shadow is constantly changing, I wait until it happens to fit the scheme of my painting and then quickly block in the shadows with a thin colour of the right tone. Establishing the principal areas of tonal contrast first is the way I begin a painting, and I try not to alter these too much. Drastic modifications can lose the spirit of the initial idea.

A border of varied bright, colourful flowers is naturally harmonious, but achieving this in a painting is not always successful and often results in a spotty effect. Reducing the brightness by lowering the tone value will ensure harmony of colour. Adding black is one way to subdue a bright colour, but too much will make it lifeless. I prefer to reduce a bright colour by adding a complementary or a darker colour in the same range: for example, yellow ochre or raw sienna added to lemon yellow or cadmium yellow, alizarin crimson to cadmium red, etc. Experiment by adding darker shades of the same colour family.

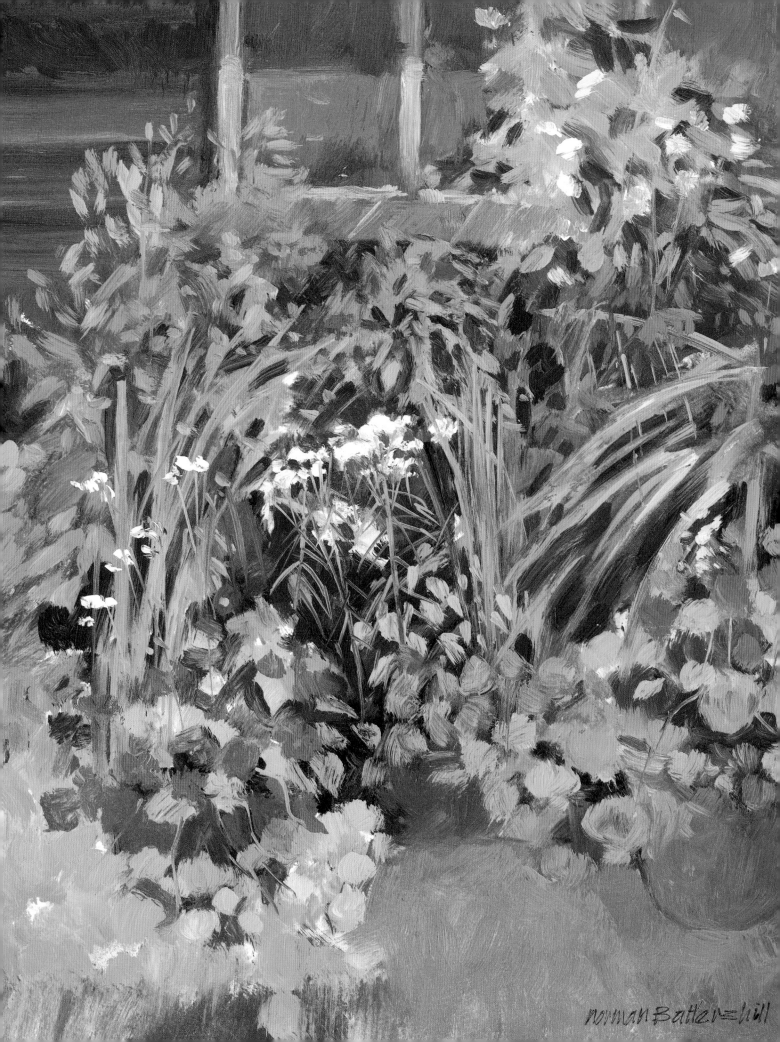

norman Battershill

When I paint massed flower borders of varied colours I invariably add some white flowers whether they are there or not. The touch of white adds sparkle and harmonizes the colour scheme. As I have already mentioned, I generally begin a garden painting in oil or acrylic with just three colours – red, blue and yellow – as well as white. I increase the range of colours as the painting progresses.

Green is the principal colour of gardens and the English landscape, and presents a major problem to some painters. Whether you use green straight from the tube or mix it from blue and yellow, a key to harmonious green is to add red or any other colour with a strong element of red in it, such as burnt sienna, light red, burnt umber, alizarin crimson, violet, etc. Instead of modifying green and other colours with black, try the more lively indigo, Payne's gray and other greys.

Painting flowers in a glasshouse has the advantage of being in the warm and protected from the elements. The pool of natural light is generally flat, without much contrast of light and shade, and judging the tonal value of flowers is therefore slightly easier.

When you paint flowers indoors, it is worth remembering that some species begin to droop very quickly, so progress the painting of the flowerheads first. Wildflowers in particular do not like being taken from their natural habitat.

Establishing the pattern and shape of the arrangement with a stain of the appropriate colours and tones is the first step, and provides a basis on which to build your painting. Leaving some of this thin colour in the finished painting has advantages, as the transparent stain gives a rich luminosity and depth to both light and shadow. I apply this technique particularly when I am painting a mass of dark foliage.

To keep bright colours clean and fresh, I often use two palettes, one for flower colours and the other for the darker colours of foliage, etc. Bright colours can be made duller but dull colours cannot be made brighter, so start off a flower painting with bright colours. Simplifying what you see adds strength and impact to a painting. Important large shapes and principal tone values are more easily assessed by half-closing your eyes.

I have included further hints and tips with the following illustrations.

(Opposite) MIXED FLOWERS.
Oil on acrylic-primed watercolour paper, 318 × 262 mm
(12½ × 10¼ in.)

I found this delightful group of flowers by the kitchen door in a friend's garden. The small space was mostly taken up by a shed, but the cramped area seemed to make the subject more intimate. I decided to paint it in oil to try to capture the richness of colour.

I started by roughing in the composition with diluted French ultramarine and cadmium red. I used the same colour for the deeper shaded areas.

As the shed window was too assertive, I obliterated part of it by extending a plant to balance the composition.

I intended to finish the painting in one session, so I painted as direct as possible, working wet-into-wet all the time.

The oil colours that I used were French ultramarine, cobalt blue, burnt sienna, mauve, cadmium orange, cadmium yellow pale and titanium white. I did not use any painting medium.

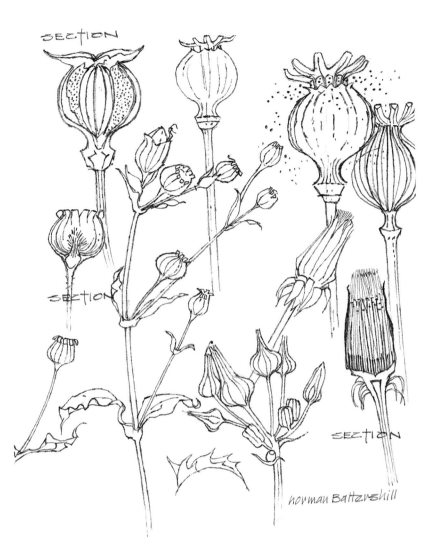

SECTION

SECTION

SECTION

SECTION

norman Battershill

type of detailed work fascinating.

(Opposite) 'BUSY LIZZIE'. *Watercolour on smooth white card, 140 × 292 mm (5$\frac{1}{2}$ × 11$\frac{1}{2}$ in.)*

Making flower studies indoors is a very good preliminary to painting flowers outdoors. It helps you to understand the structure and growth of different plants, and is also a way of building up your confidence in painting and drawing flowers.

You may wish to put a lot of detail into your work, but the danger is that it may look too busy and over-fussed. My watercolour of a 'busy Lizzie' is very much simplified, but there is no mistaking what kind of flower it is.

I did this watercolour without any preliminary drawing. First, I put in all the flowers with a single wash of colour. When this was dry, I painted the leaves in a single colour. The final touches were to add slightly darker tones to the flowers and leaves. It is very tempting to go on and build up detail, but I wanted to keep this study fresh and simple, so I left well alone.

(Above) STUDIES. *Pencil on Bockingford watercolour paper, 223 × 190 mm (8$\frac{3}{4}$ × 7$\frac{1}{2}$ in.)*

In the winter months there is the opportunity to study dried flowers and seedheads from the garden. A section through a seedhead reveals the wonderful secret world of nature, but to see it clearly a strong magnifying glass is necessary. I have one on a heavy metal base so that it can stand securely on my drawing-board

without falling off, and I also have a jeweller's powerful eye-glass that is extremely useful for very close-up studies.

The section through a dried poppyhead is a revelation of nature's method of seed dispersal. Even the slightest movement sends the tiny seeds through the apertures at the crown of the poppyhead. I have shown this action on the right of my page of studies. Next to this is a sketch of the delicate framework. I find this

(Right) SCENTLESS MAYWEED.
Acrylic on canvas, 231 × 184 mm
(9 × 7¼ in.)

I am reluctant to destroy this delightful weed, so it is left to grow quite happily on the terrace and in the gravel courtyard. It reminds me of a similar daisy-like plant that I found growing among the volcanic wastelands of Lanzarote.

Looking down on the flowers against a background of pebbles and fern-shaped leaves created an interesting contrast of textures. I simplified my painting a good deal, but still retained the character of the plant. Remember that it is not always necessary to include all that you see.

The colours that I used for this acrylic painting were French ultramarine, cadmium yellow medium, cadmium red, raw sienna and titanium white.

A SUMMER GARDEN.
Acrylic on hardboard (Masonite),
610 × 762 mm (24 × 30 in.)

I painted this colourful subject
outdoors on a wonderful
summer day in a lovely garden
on the Dorset coast. The sky
was an intense cobalt blue
which would not have suited
the tonal key of my painting,
so I made it a warm grey as a
neutral foil to the bright flower
colours.

There was a brick
summerhouse at the end of
the path, but I altered this to
a background of shrubbery
to create a feeling of further
depth.

To lead interest into the
painting, I added a foreground
shadow and angled it to
contrast with the horizontals of
the steps. White adds sparkle to
a garden painting, and the large
daisy bush gave the necessary
accent here. I balanced this
with smaller touches of white
to the left. These may seem
small modifications, but
they do contribute to the
completeness of the picture.

A criticism of acrylic is that
it dries too quickly, but I
completed this painting on a
hot summer day in one session
without any problems. So
don't be put off acrylic because
of this criticism – you can
make it work for you too. The
colours that I used for this
painting were French
ultramarine, cadmium red,
cadmium yellow, cadmium
orange, deep brilliant red,
cobalt blue, yellow ochre and
titanium white.

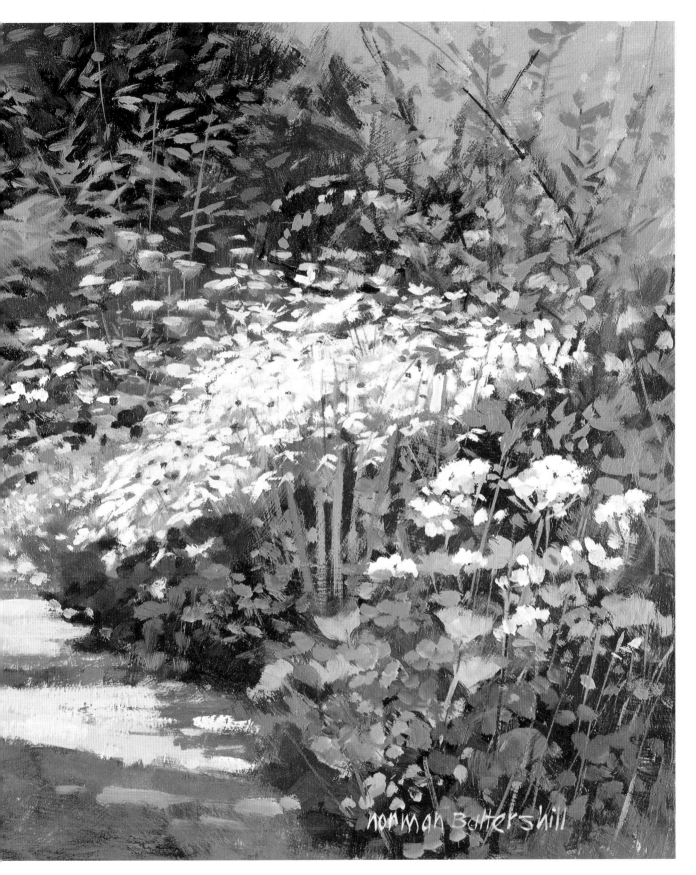

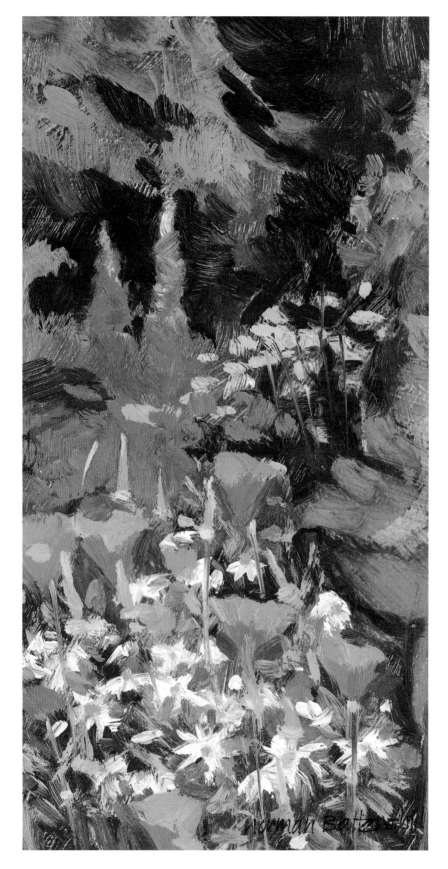

CALIFORNIAN POPPIES.
Oil on hardboard (Masonite),
reproduced actual size

The wonderful, rich colour of the Californian poppy gave me the idea for this small oil painting. There was a mass of these brilliant orange flowers in the border, but I selected only a very small area to emphasize their colour and shape. The tall, narrow composition makes the subject more intimate than a horizontal format. I had to simplify this subject a great deal, as too much detail would have made the painting fussy and detracted from the poppies.

Before starting to paint, I stained the board with a mixture of French ultramarine and cadmium red for the darks at the top of the painting. I mixed French ultramarine and yellow ochre for the lower part, as an underpainting to the foilage. I left some of the underpainting showing in the final stages of completion.

My oil painting is reproduced actual size. A larger painting loses the quality of brushwork when it is reduced for reproduction, and so I prefer to work on a small scale to illustrate the painting technique. The colours that I used were cadmium red, cadmium orange, cadmium yellow, cobalt blue, French ultramarine, alizarin crimson and titanium white.

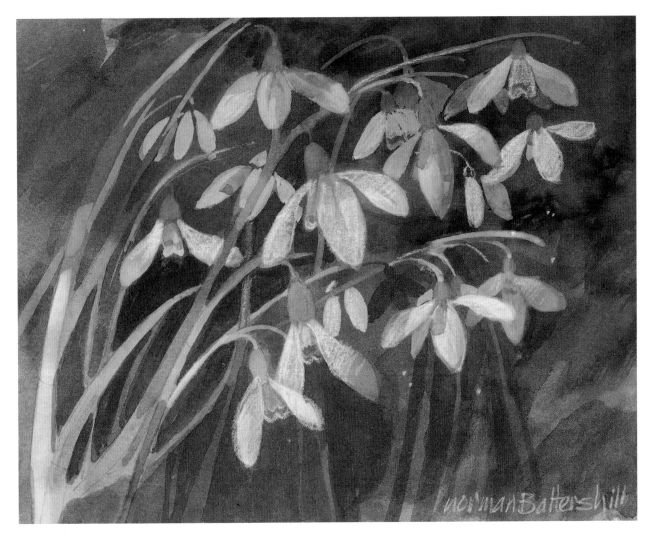

SNOWDROPS
Watercolour and white pencil on
white card, 150 × 178 mm
(5¾ × 7 in.)

I rescued a clump of snowdrops from a garden about to be flattened by a bulldozer. My painting is of only a small part, but it typifies the beauty of these delicate flowers. I began this watercolour with a dark background of French ultramarine and cadmium red, but when I had finished it I did not like the stark white of the snowdrops.

The painting seemed doomed to failure and I started to wipe it all out with a damp cloth, but the resulting stain over the flowers from the background colour gave me the idea that all was not yet lost. I realized that reducing the brilliant white of the snowdrops to a much lower tone might be more successful, so I worked over the flowers with a white pencil, leaving some of the background stain on the petals. Here and there I also added some thinned gouache.

The final result was more pleasing than my first attempt.

DEMONSTRATION

SUMMER FLOWERS.
Mixed media on smooth white card, finished painting
180 × 242 mm (7 × 9½ in.)

I chose the mixed-media combination of watercolour and soft-chalk pastel for my garden-painting demonstration. I have reconstructed the separate stages to show you how I progressed to the finished painting.

Stage 1

First, I washed clean water over the white card. While it was still damp, I brushed in pale cadmium yellow with a one-inch hake brush. After this had dried, I established the darkest tone in the background and middle tones in the foreground, using the same brush.

Stage 2

The overall tonal value of the painting – the critical element of a balanced composition – began to take shape as I added further colours and began to define the central area. The card was absorbent, limiting the wet-into-wet technique, so I had to get it right first time.

Stage 3

Still using the one-inch hake brush, I completed the placing of all the big shapes in watercolour. At this stage it is easy to overdo it by adding unnecessary further work, so I decided that it was time to change to pastel. Watercolour and pastel go well together and suited my broad technique for this subject. The white card was smooth, but the watercolour washes gave a surface for pastel which was just right.

The finished painting

Once the watercolour had dried thoroughly, I began to apply the pastel. I left areas of the original watercolour untouched to give the tonal unity that I had established in the first stages of the painting. The globe thistle in the foreground and the golden achillea behind it gave a sense of rhythm which counterbalanced the angles and horizontals.

The colours that I used for the watercolour stages were French ultramarine, cadmium yellow and burnt sienna.

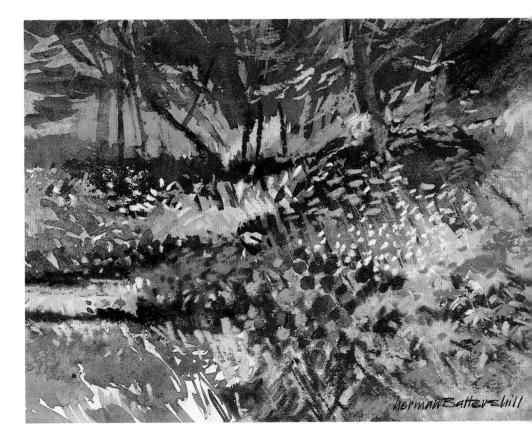

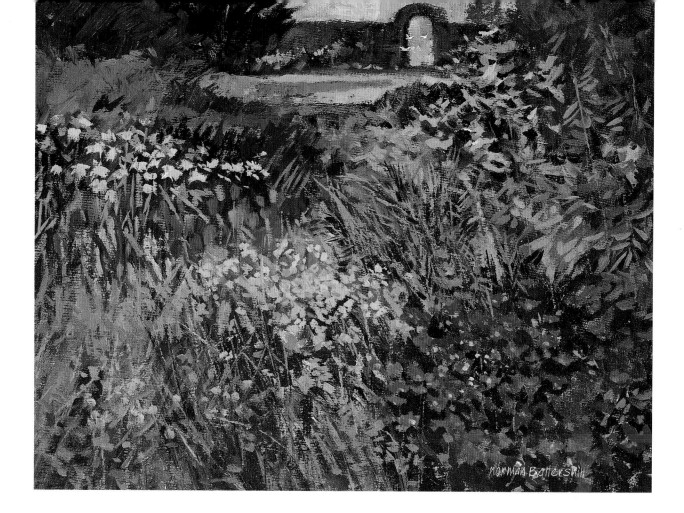

COLOURS OF SUMMER.
Acrylic on hardboard (Masonite),
381 × 508 mm (15 × 20 in.)

The composition of this painting is interesting because of the way the flowers lead to the shadow on the lawn, which in turn leads to the arch and beyond. I added the doves to give movement and to increase the sense of distance. I was lucky with this painting because the position and contrast of light and dark suited the composition of the subject.

There was a line of trees in the background, but I changed these for the tall hedge and archway. Artistic licence in this case added further depth and interest to the garden. The acrylic colours that I used were

French ultramarine, purple, cadmium red, deep brilliant red, burnt sienna, azo yellow medium, cadmium yellow and titanium white.

(Opposite) PRIMULA.
Unison soft-chalk pastel on grey Tiziano pastel paper,
305 × 229 mm (12 × 9 in.)

Primula ready for planting out gave me the idea for this pastel painting. The colour scheme is basically yellow, so I had the opportunity for bold complementary mauve shadows.

The rusted trowel had seen better days but added some

character to the simple composition. I gave very careful consideration to its position, as it forms a forceful diagonal. I placed this in line with the direction of the flowerpots, but not exactly at the same angle. Although it may seem trivial to consider the alignment of the trowel, it does form an important part of the composition. The cast shadows counterbalance the verticals and angles and also add movement.

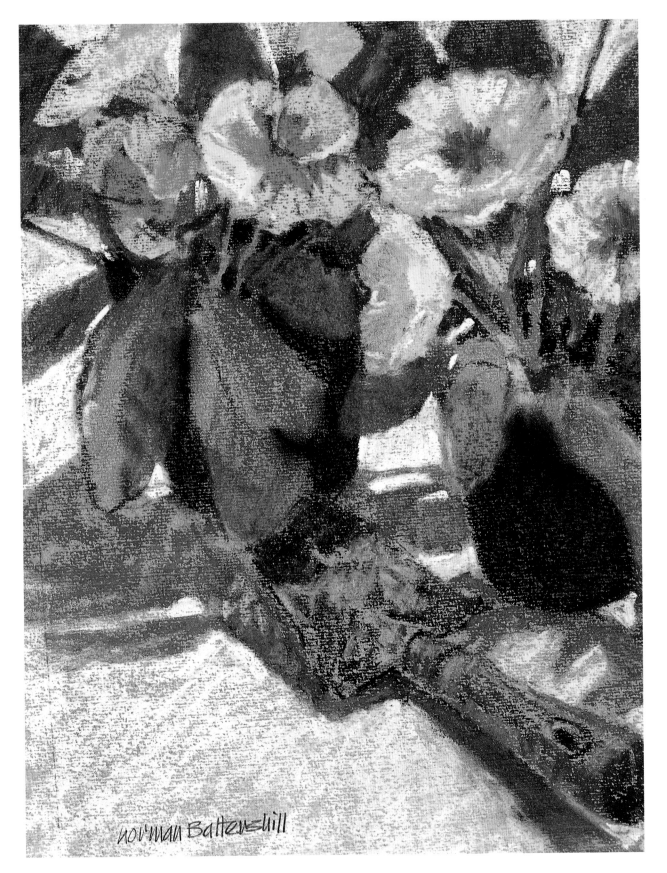

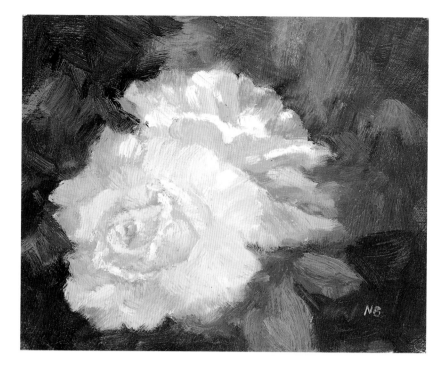

ROSES.
*Oil on acrylic-primed hardboard
(Masonite), 115 × 141 mm
(4½ × 5½ in.)*

The beauty of a rose is one of
the most difficult subjects to
capture in paint. For this small
oil painting I endeavoured to
give an impression of softness
and light.

My first step was to paint in
a transparent wash of lemon
yellow diluted with turpentine
for the base colour of the yellow
rose. I used diluted alizarin
crimson for the pink rose. The
stain of pure colour soon dried,
and I was then able to establish
the background with a thinned
mixture of French ultramarine
and cadmium red. This dark
tone and the light wash of
colour for the roses gave me a
tonal scale to work from.

For the yellow rose I used
cadmium yellow, cadmium

lemon and raw sienna, and
added the slightest touch of
alizarin crimson to harmonize
with the pink rose. Alizarin
crimson is a strong, rich colour,
so I was able to mix a lot of
white with it without losing its
hue. Touches of yellow increase
the effect of sunlight in the
composition, and also relate to
the yellow rose below.

The background foliage was
well-defined in the bright
sunlight. To paint it as I saw it,
however, would have taken
interest away from the roses, so
I gave an impression of leaf
mass instead. The colours that I
used for the background were
French ultramarine, cadmium
red, alizarin crimson, raw
sienna and white. While it was
still wet, I blended the edges of
the roses to achieve a softness.
The blurring creates an effect of
depth and adds to the illusion
of soft light. A rose is a

complexity of interlocking
petal shapes and is not an easy
subject, but luckily my painting
went right first time, and I
achieved the effect that I
wanted.

(Opposite)
BUTTERCUPS AND CAMPION.
*Oil on hardboard (Masonite),
610 × 508 mm (24 × 20 in.)*

A cluster of wildflowers against
a rich, dark background is the
subject of this outdoor oil
painting. It was one of the
happiest experiences I have had
painting outdoors. The subject
was perfect and conditions for
working ideal without any
interruption, and it turned out
right first time.

I laid in the dark background
first to establish the tonal key
of the painting. This was a
dilute mixture of French
ultramarine and cadmium red,
which, because it was thin,
began to dry fairly quickly. I
was then able to paint over the
dark ground with lighter
colours without muddying
them. As the painting
progressed, I built up the
background with thicker paint.

Saving the flowers until last
was a real treat – like putting
icing on a cake. I mixed thick
paint of clean colour and
applied it direct. The oil
colours that I used were French
ultramarine, cadmium red,
alizarin crimson, yellow ochre,
burnt sienna, cadmium lemon,
cadmium yellow, cobalt blue
and titanium white. To make
all the greens harmonious I
mixed blue and yellow and a
touch of burnt sienna.

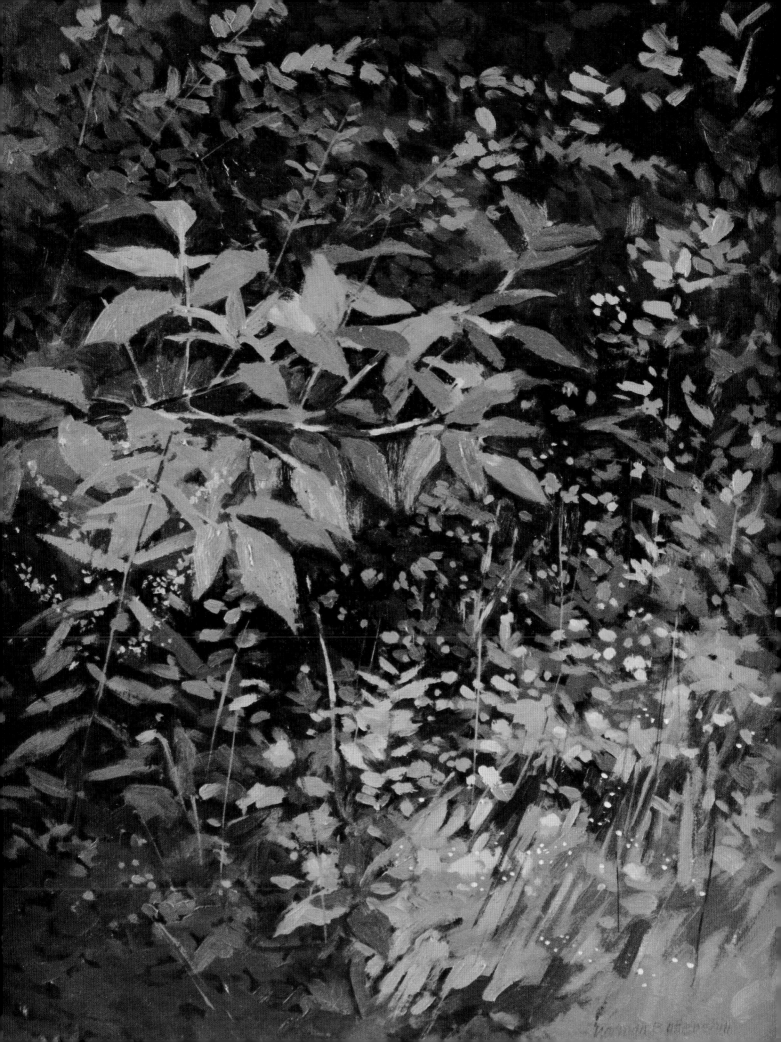

ASPECTS OF WATER

ater is one of the most pleasurable subjects that an artist could wish for. The inclusion of still water in a garden increases the illusion of space by reflecting light and the changing moods of the skies. The repetitive sound of gently moving water adds to its visual delight. The movement calms the spirits and has a contemplative effect on the senses.

An aspect of water in a painting has a special appeal, and the ability to paint it well should be within the scope of every painter of gardens. To the inexperienced painter, moving water and reflections present the greatest problems, but the following principles which I adopt to simplify this complex subject will be of interest.

Before I start painting I spend time studying the intricate pattern of moving water. The most important part of this observation is to define the character of the movement, which is determined by the force of the water flow. Perhaps it may be just a lazy trickle tumbling over stones, or a powerful cascade with strong curving shapes.

Falling water involves a complexity of interwoven, subtle movements. At first glance shapes seem to repeat themselves, but, although they are repetitive, the curving patterns are never exactly the same. It is difficult to focus attention close up on a part of moving water, and so to isolate one area from another I use a viewfinder, with an immediately dramatic and beautiful result. By separating part of the movement of water in this way, the beautiful pattern of shapes and reflected light immediately becomes

(Opposite) FOUNTAIN.
Unison soft-chalk pastel on dark grey Tiziano pastel paper,
305 × 216 mm (12 × 8½ in.)

The background to this water study was green shrubbery and a mass of flowers, but, as the stone trough and the fountain were complete in themselves, I decided to leave the background out. It is not always necessary to paint all that you see.

I also made the stone trough darker than it really was to give a more dramatic contrast of light and dark. The dark background harmonizes with the foreground and links them together.

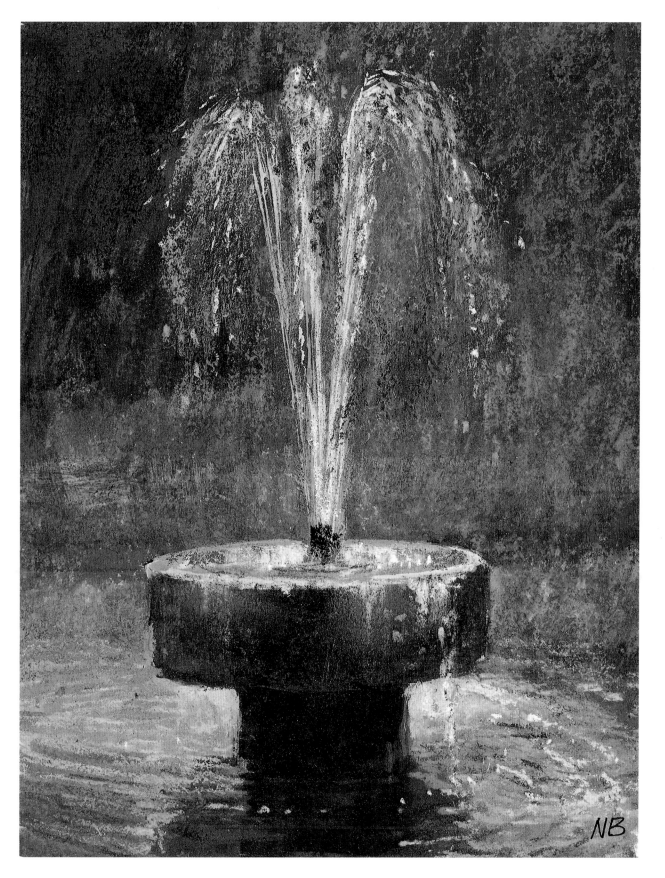

apparent. This method of a close-up study of moving water is inspiring and has given me ideas for several paintings. One of the most fascinating features of falling water forms at its base. The spreading-out movements of ripples, bubbles and white water is wonderful to paint. As with any water subject, simplifying what you see is more likely to capture the spirit of movement than a photographic representation.

It may sometimes be difficult to estimate the correct tone value of reflections when painting water. The general rule to remember is that a light tone has a darker reflection and a dark tone a lighter reflection. Judging the right tone values is made easier if the darks are established first.

The scope for water subjects is tremendous, ranging from the grand classical design to the simple fishpond in a suburban back garden. One of the most interesting and simple subjects I have painted is the reflection of clouds and sky in a bucket of water.

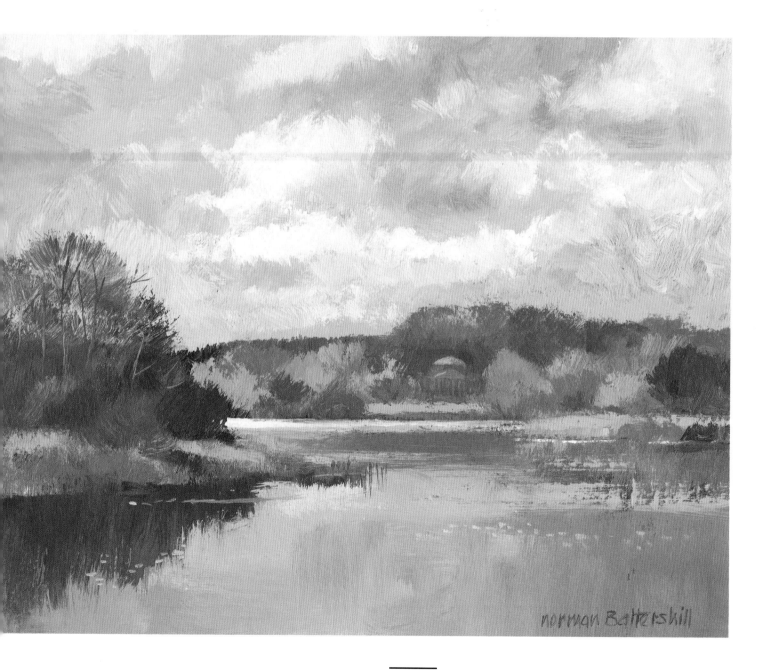

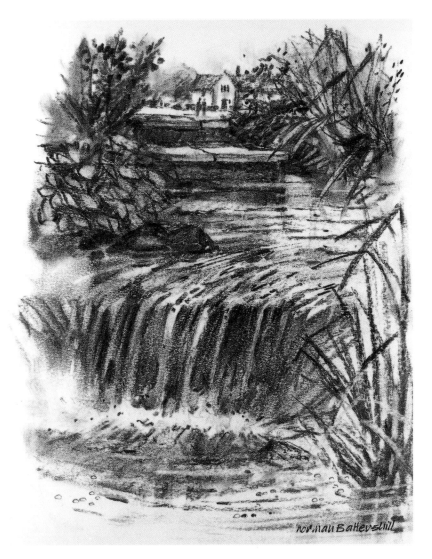

(Opposite) STOURHEAD.
*Oil on Bockingford watercolour
paper, 229 × 279 mm
(9 × 11 in.)*

The magnificent lake at the
National Trust's Stourhead
garden, with the elegant
pantheon in the background, is
the subject of this oil painting.
Wherever you walk along the
perimeter of the great lake,
there are many interesting
viewpoints from which to
paint. I chose this view because
the expanse of water is seen
to advantage. The distant
pantheon gives scale to the
setting and a focal point
without being obtrusive. I
endeavoured to capture aerial
atmosphere with a rugged sky
of cumulus cloud and a
contrasting calm stretch of
water reflecting light from the
sky.

The colours that I used were
French ultramarine, cobalt blue,
cadmium red, light red,
cadmium yellow, raw sienna
and titanium white. I made my
painting quite small to avoid
too much reduction in the
reproduction, and the
consequent loss of brushwork.

WATERFALL.
*Charcoal on cartridge paper,
231 × 190 mm (9¼ × 7½ in.)*

The charcoal drawing shown
above is an example of different
surface textures of water, and is
an imaginary subject. At the
lower level, the cascade falls
into white water and breaks
into widening ripples. I have
endeavoured to show the force
of the water by the density of
the cascade. The vertical reeds
in the lower pool also help to
emphasize the downward
movement of the water. The
water at the back of the upper
pool is calm, as indicated by
the clear reflection of the step.

Before you start painting or
drawing water, spend some
time analysing the character of
its movement. If you can
capture this movement your
brushwork will have vigour.

47

DEMONSTRATION

WATERFALL.
*Oil on primed card, finished
painting 178 × 242 mm
(7 × 9½ in.)*

I have reconstructed the separate stages of this painting so that you can see how it was carried out. The subject is an imaginary studio painting. Before starting to paint, I primed a piece of thin white card with acrylic gesso primer.

Stage 1

I blocked in the principal shapes with a mixture of thinned French ultramarine and cadmium red. This established the pattern of the composition.

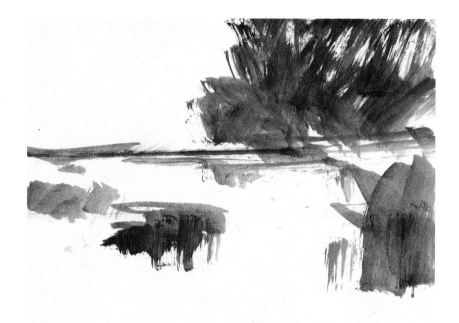

Stage 2

I used a thin mixture of French ultramarine with a touch of white and cadmium red for the background trees. I positioned the grass and right-hand shrub, but without any regard to detail; at this stage I was only interested in the big shapes.

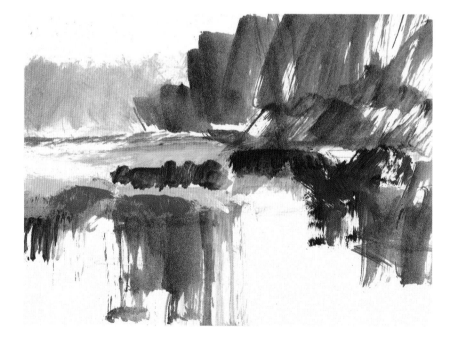

Stage 3

It was then time to start pulling the painting together. I added more colour, indicated the reflections and counterbalanced slender trees with the big masses. Before starting to paint I had decided that the light effect would not be contrasting, so I left the sky alone at this stage.

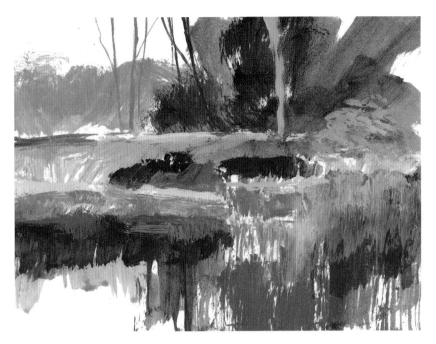

The finished painting

Now I could fit the sky to the subject, and for this I used raw sienna and white over an undercolour of grey. I began to see the completed picture in my mind and added the waterfall, rocks and water irises. I dry-brushed the big tree trunks to suggest texture. Mixing a slightly darker version of the sky colour, I painted over the reflections.

In the final stages of a painting it is tempting to 'tidy it up', but I resisted this and completed my picture without adding unnecessary detail.

The colours that I used were cadmium red, French ultramarine, raw sienna, burnt sienna, cadmium lemon, cobalt blue, cadmium green and titanium white. I made the painting fairly small so that you can see the brushwork more easily.

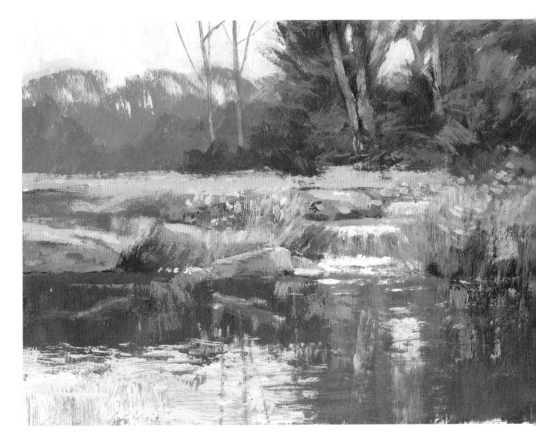

EARLY MORNING.
*Pastel on grey Tiziano pastel
paper, 229 × 330 mm
(9 × 13 in.)*

My studio painting is of an imaginary setting, based on memories of a stately home I once visited and some sketches of the nearby River Stour. Creating a successful studio painting from your imagination is very satisfying, but success can only be achieved by consistently working outdoors, because in this way your visual memory will develop.

For this painting I tried to create an atmosphere of early morning when all is still and quiet. I began by blocking in the composition and darkest tones with charcoal. This method has the advantage of establishing a tonal pitch on which to build your colours (the same principle as placing the darkest tones first in oil painting).

The silhouetted trees in my painting are an important part of creating atmosphere. Too much detail would not fit in with the mood of the subject. The bridge adds interest and enhances the sense of scale and distance without being obtrusive. I added the streak of sunlight as the final key to the painting. For this kind of atmospheric subject, I do not think that soft-chalk pastel can be equalled.

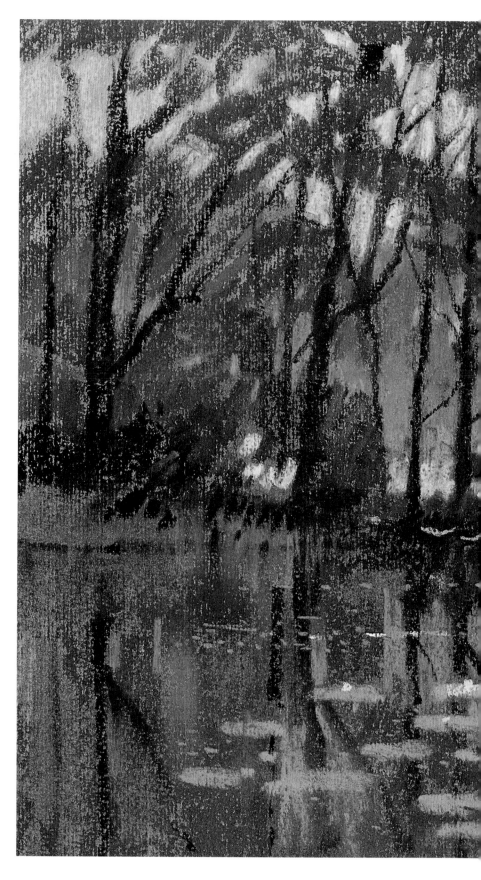

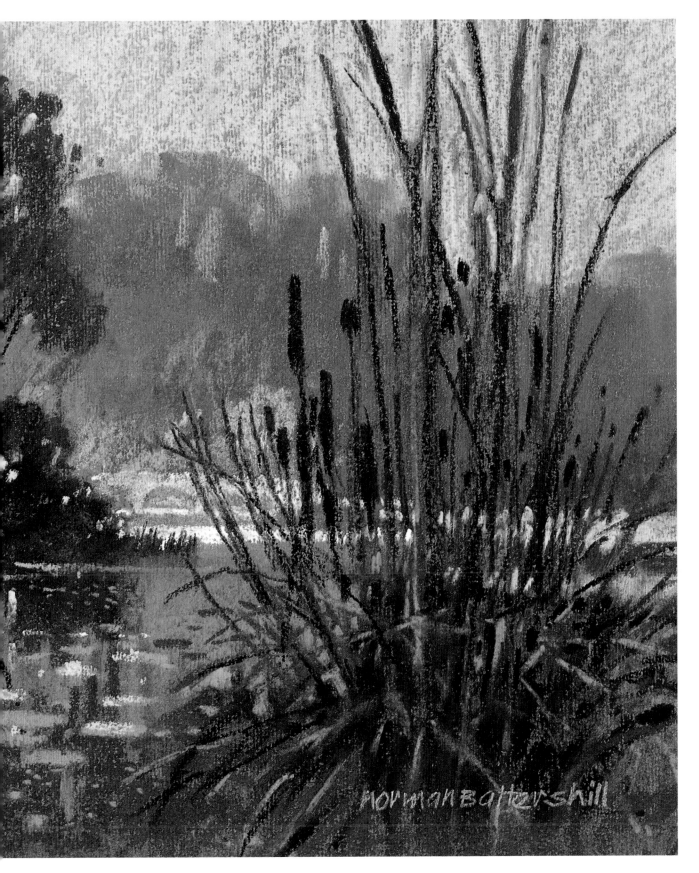

FOUNTAIN.
Acrylic on hardboard (Masonite),
305 × 229 mm (12 × 9 in.)

The gentle curves of this classical garden setting are in perfect harmony with the shape of the fountain. I avoided distracting detail in the background of the trees to emphasize the height of the water jet. The garlands of foliage between the stone columns and other subtle curves of the design all add to the beautiful rhythm. I could not have wished for a more complete subject.

First, I stained the board with a diluted wash of acrylic mixed from cadmium red and French ultramarine. The dark tone gave me the tonal key for the fountain, which I left until last. My next step was to establish all the big shapes and gradually to build up the overall pattern.

With a subject like this, which is full of small detail, it is easy to overdo it and become finicky. To avoid this I used just one brush for most of the painting: a Winsor & Newton oil colour no. 4, which is a long, flat bristle brush. For smaller work I used a synthetic Sceptre brush no. 4, series 101.

When I paint a jet of water, I first establish the main vertical movement, and then the curve of the fall. This method gives a structure to its shape. The advantage of acrylic drying quickly enabled me to dry-brush the effect of spray with the minimum of delay. The colours that I used were French ultramarine, cadmium red, cadmium yellow, burnt sienna and titanium white.

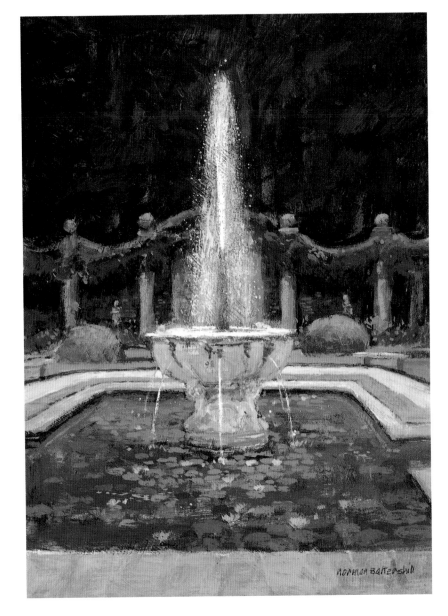

(Opposite page)
GARDEN CENTRE.
Watercolour on buff-coloured Tiziano pastel paper,
210 × 267 mm (8¼ × 10½ in.)

On my travels for this book, I was pleased to see the number of garden centres that now include an aspect of water. My

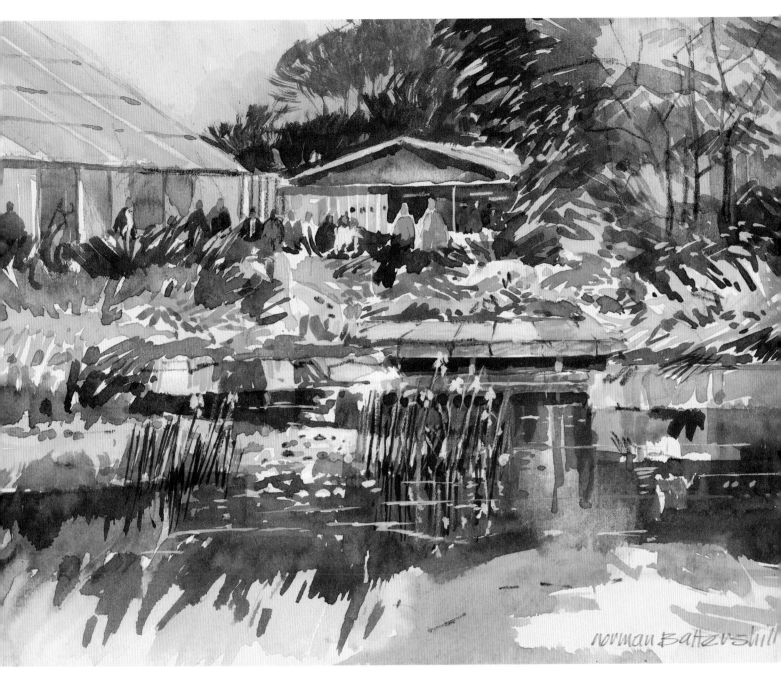

painting of a water feature at a garden centre is a studio painting from a photograph that I took during the summer, when it was far too crowded to paint or even sketch.

Although there was a great deal of bright colour, I lowered the colour key to create harmony. I diluted the paint with plenty of water, and the buff-coloured paper showing through has a sunny effect.

The flat sky makes a restful area from the lively brushwork and busy setting. I added a touch of white to the sky colour to make a contrast of transparent and opaque colour. The watercolours that I used were Payne's gray, French ultramarine, cadmium red, cadmium yellow, yellow ochre and burnt sienna.

REFLECTIONS: PENCIL STUDY.
Carbon pencil on blue Tiziano paper, 231 × 180 mm (9 × 6¾ in.)

Reflections on moving water are intricate and very complex to draw. For this study I took a photograph and did the drawing from it in the studio. I wanted to make an accurate recording of the pattern, and this cannot easily be done outdoors.

I have included this study to illustrate the beautiful abstract quality of a reflection in moving water. Whichever way you turn the page, the pattern seems to be balanced. I can visualize the impact of this drawing if it were reproduced as a large painting.

Working from a photograph is a particularly good exercise for understanding reflections, but it is essential to be selective and delete all unnecessary detail. Try to make your drawing spontaneous and not overworked.

(Opposite) FISH POND.
Oil on hardboard (Masonite), 406 × 254 mm (16 × 10 in.)

The subject of this outdoor oil painting is a large rockery in a Dorset garden. I chose a close-up view to show the different textures and levels. To establish a ground colour on which to work, I stained the primed board with a diluted wash of raw sienna, and then all the darkest tones with French ultramarine mixed with cadmium red.

I retained the initial stain of raw sienna for the rocks, and overpainted opaque colours of grey and yellow ochre. The reeds are an important aspect of the composition. The strong verticals counterbalance the bold horizontals of the rocks and repeat the movement of falling water. I indicated the goldfish breaking the surface of the water with small touches of pure cadmium orange. I left the fall of water until the very last stages so that I could judge the tonal values accurately.

The colours that I used were raw sienna, yellow ochre, French ultramarine, cadmium orange, cadmium yellow, burnt sienna and titanium white.

REFLECTIONS.
Pastel on mid-grey Tiziano pastel paper, 152 × 229 mm (6 × 9 in.)

My painting shows a very small part of a large, rock-filled pool. I selected this area because of the reflections, the patch of light and the simplicity of composition.

Although the background was lighter in tone, I made my painting much darker to contrast the rich tones with the small area of reflected light from the sky. I left the mid-grey paper showing through in some places on the rocks.

I established all the darks first, and then fixed the pastel with aerosol fixative. After several light applications I was able to work on the reflection of the sky without the undercolour lifting. The final touches were the few autumn leaves on the surface of the pool.

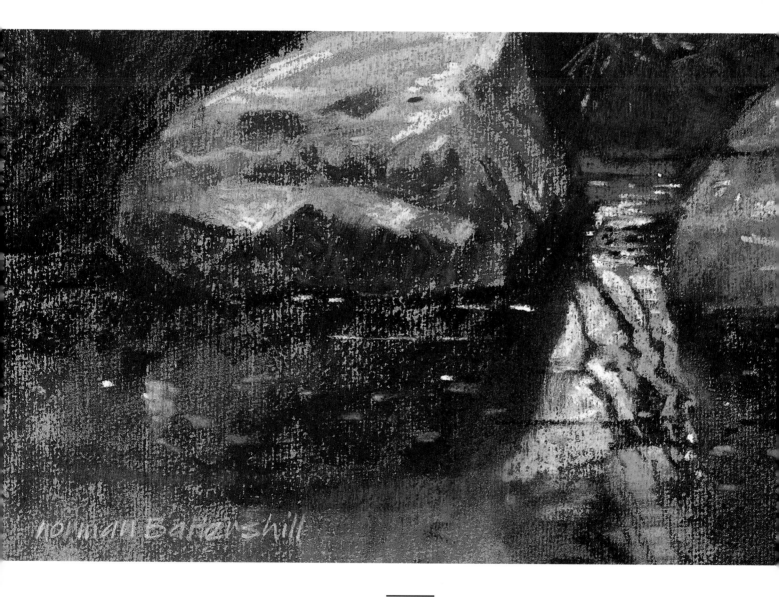

VEGETABLE GARDENS

Flowering sweetpeas, leafy carrots and the bold shapes of cabbage and lettuce leaves are a few of the visual delights in a flourishing vegetable garden. You are not confined to painting vegetables: cold frames, cloches, greenhouses and netted fruitcages also add to the great variety of very painterly subjects that you can find there. Before I begin a painting, I like to walk around for a while to absorb the atmosphere and environment that surround me. Time spent in this way is a very important part of painting outdoors.

The traditional planning of a vegetable garden is based on a simple rectangular form, with all divisions and borders in straight lines forming right angles to each other. This geometric layout has advantages for the artist. By selecting a vantage point looking down the lines of vegetables, paths or borders, we can create depth in a painting by applying the principle of diminishing perspective. If the vegetable garden is intersected by paths, we also have the advantage of being able to get close to our subject without damaging the crops. A seated, low viewpoint is often much more interesting than a standing position.

When they are allowed to flower, many vegetables add vibrant colour and beauty to the garden and also the home. Of these the globe artichoke is the most dramatic, with its rugged globe and purple flower. The association of varied textures and fresh colours of foliage all add to the beauty to be discovered in a vegetable garden.

The traditional kitchen garden faces south to catch the warmth of the sun and is bounded by high brick walls to contain the warmth. Unfortunately, very few of these picturesque gardens remain today, but if you are fortunate enough to discover one, do not miss the opportunity to do some painting or drawing.

My oil painting overleaf is an example of a lovely old kitchen garden that I discovered some time ago. I painted this picture on my day off from running a painting course, and I can still recall the peaceful warmth of this delightful old-fashioned kitchen garden. The atmosphere of a past elegant era was with me all the time I was painting.

Fruit trees were at one time an integral part of a garden, for the home required fruit as well as vegetables. Even just one tree in the garden is a visual pleasure and a delight to paint in all seasons. I have a very happy memory of painting an old apple tree laden with fruit on a summer's day in a Dorset coastal garden.

If garden space is too limited for standard fruit trees, the cordon system of growing flat-trained trees has appeal for the painter. Peaches, pears, apples, plums and nectarines are some of the different varieties grown by this method. As well as being advantageous to the grower, this gives the artist the opportunity of painting blossom and fruit at close quarters. A trug or basket full of vegetables, or vegetables grouped on a weathered table top, are also subjects that I have enjoyed painting outdoors on several occasions. A sunny day is best for contrasting tones, but remember that shadows may change quickly.

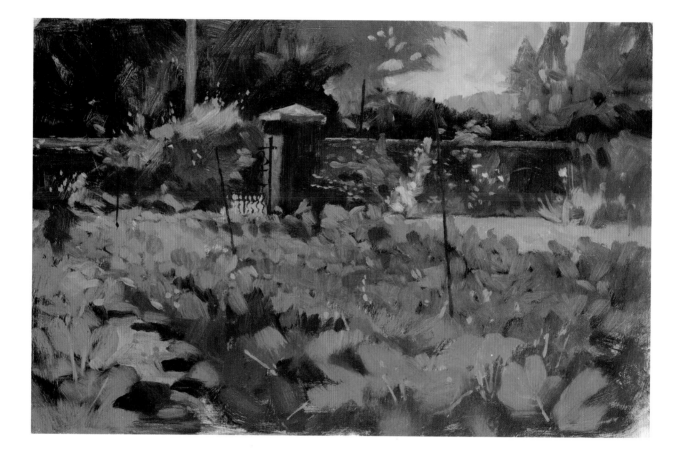

KITCHEN GARDEN.
Oil on hardboard (Masonite),
203 × 305 mm (8 × 12 in.)

The kitchen garden illustrated above is an outdoor painting that I did on my afternoon off from tutoring a painting course in Hartpury. The rich texture and colour of vegetable leaves attracted my attention to this peaceful setting.

With a busy painting, it is necessary to have an area of rest; here, the small patch of lawn provides the counterbalance. This is an interesting composition of dominant angles and horizontals, but it is all harmoniously balanced. My palette for the oil painting consisted of French ultramarine, cadmium yellow, Prussian blue, burnt sienna, cadmium red, yellow ochre and titanium white.

Although I painted the picture some time ago, I have included it here as an example of an old-fashioned kitchen garden, unfortunately rarely found these days.

TERRY'S VEGETABLE GARDEN.
*Watercolour on white card,
reproduced actual size*

The cold frame in the
foreground tied back with
orange-coloured twine was
really the subject for my
watercolour. Rows of
vegetables lead into the
background, creating interest
with varied textures and tones.
To give an effect of glass, I
overpainted with a translucent
wash of opaque white mixed
with Payne's gray when the
background had dried. The
card that I used is fairly
absorbent, which limits the
wet-into-wet technique but
encourages a direct approach,
which I prefer.

I made the tree darker in
tone than it really was to avoid
too much emphasis on the
horizontals of the composition.
This, along with the beanpoles
and the foreground stake,
counterbalances the horizontals.
I made the background fairly
dark on the left, and this draws
interest into the painting and
balances the weight of the
foreground.

The colours that I used were
French ultramarine, Payne's
gray, cadmium yellow, burnt
sienna, yellow ochre and burnt
umber.

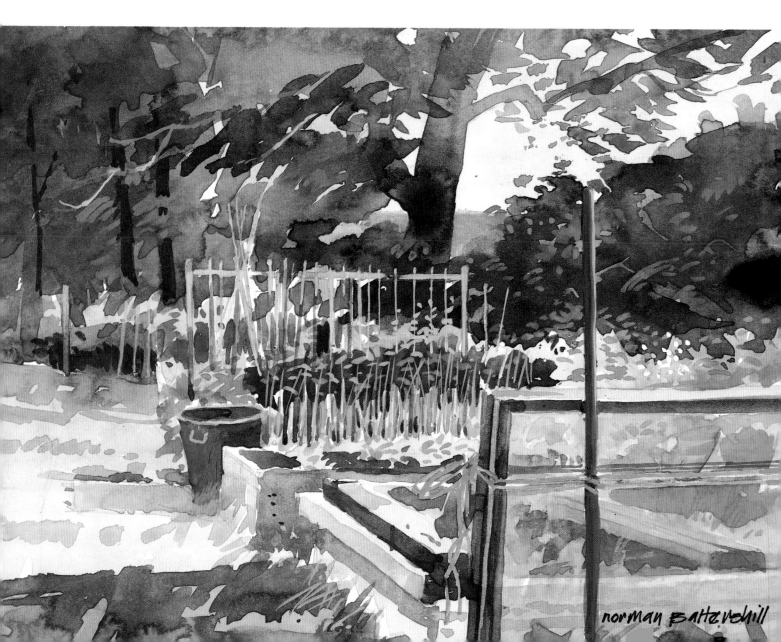

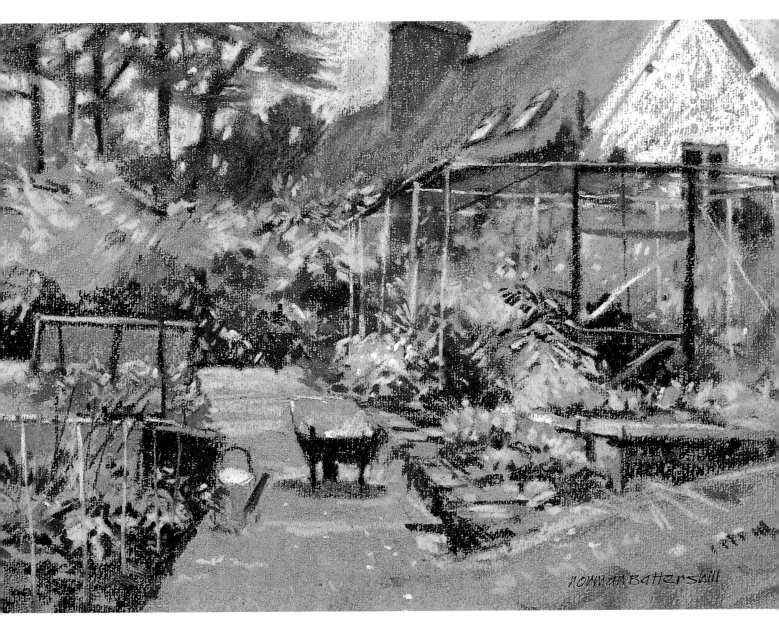

TERRY'S FRUITCAGE.
*Pastel on grey pastel paper,
241 × 330 mm (9½ × 13 in.)*

Every vegetable garden has
unlimited scope for a great
variety of subjects. In this
garden alone I found enough
material for a whole series of
paintings. The watercolour on
page 59 is also part of the
vegetable garden shown above.

I roughed out the
composition in charcoal first
and then established the darkest
tones. With the middle tone of
the paper, I then had a basis to
build on.

The composition was rather
complicated, so I took care
to counterbalance each part
with something else. The
wheelbarrow, for example,
balances the bulk of the

fruitcage and cottage. It also
joins up the foreground. If you
cover up the wheelbarrow you
will see how effective it is in
relating one part to another.

Bringing interest into a
painting is an important aspect
of composition. I achieved this
here by the use of perspective
and by adding the touch of
bright red flowers beyond the
wheelbarrow.

BEAN STICKS.
Watercolour on smooth white card,
279 × 203 mm (11 × 8 in.)

The pattern of bean sticks and the varied shapes of leaves made an interesting corner in this vegetable patch. There were so many alternative viewpoints from which to choose that it would be quite easy to paint a series of the same subject.

The emphasis here is on the verticals, so I made the painting a vertical format for a change. Although the foreground is dominant, I balanced it with a dark background. The wigwam shape of the sticks is also an effective counterbalance. I scratched out the criss-cross of the coarse twine with a blade to achieve a rugged line.

I have previously mentioned that a busy painting should have an area of rest. In this watercolour the grass on the left provides a space to counterbalance the fussy and complicated arrangement on the right. The ellipse of the dustbin was too pronounced, so I extended the plant to cover part of it.

The colours that I used were French ultramarine, Payne's gray, cadmium yellow, light red and yellow ochre.

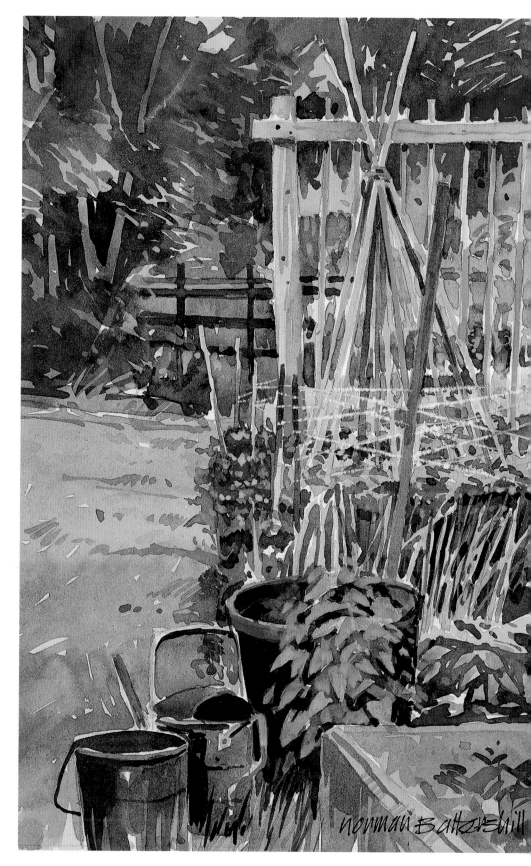

SUMMER'S FRUIT.
*Gouache on dark grey Tiziano
pastel paper, 184 × 270 mm
(7¼ × 10½ in.)*

Applying thin washes of colour on absorbent pastel paper has its problems. Gouache dries lighter, but here I also had to make allowances for the dark tone of the paper showing through.

I began by lightly drawing in the subject with a white pencil. The mark is clearly visible on dark paper and can easily be rubbed out with a putty eraser. I started to paint the apples first with a translucent wash of light green. While this was still wet, I quickly painted into it a warm reddish-brown colour. I also carried out some dry-brush blending.

Once the apples and leaves had dried, I could judge the tone of the background more easily. The apples were growing on the cordon system against a red-brick wall, but I decided that a neutral-grey background would enhance the russet colours better. I kept the background colour fairly thin to let the paper show through, as I had done for the apples. The warm colour gives the painting an overall harmony.

The designer's gouache colours that I used were French ultramarine, lemon yellow, yellow ochre, brilliant green light, cadmium red and titanium white. My brushes were a no. 5 short bristle oil–colour brush and a Winsor & Newton Sceptre synthetic brush for the detailed work.

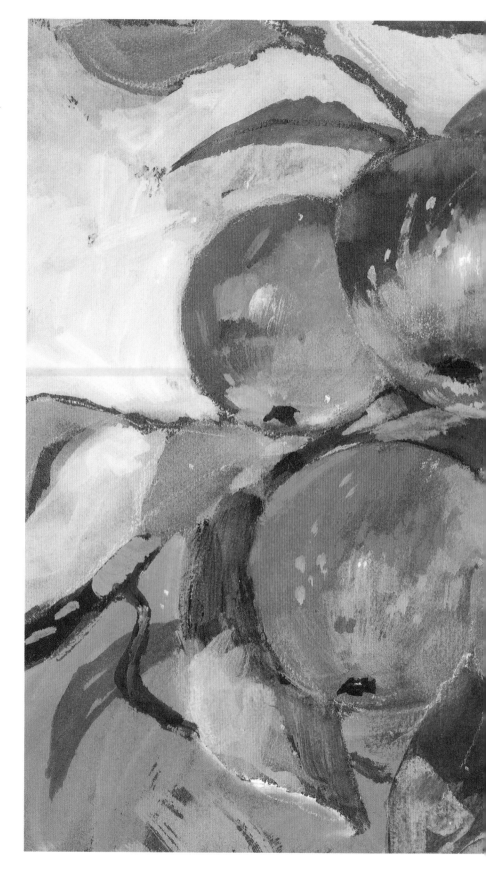

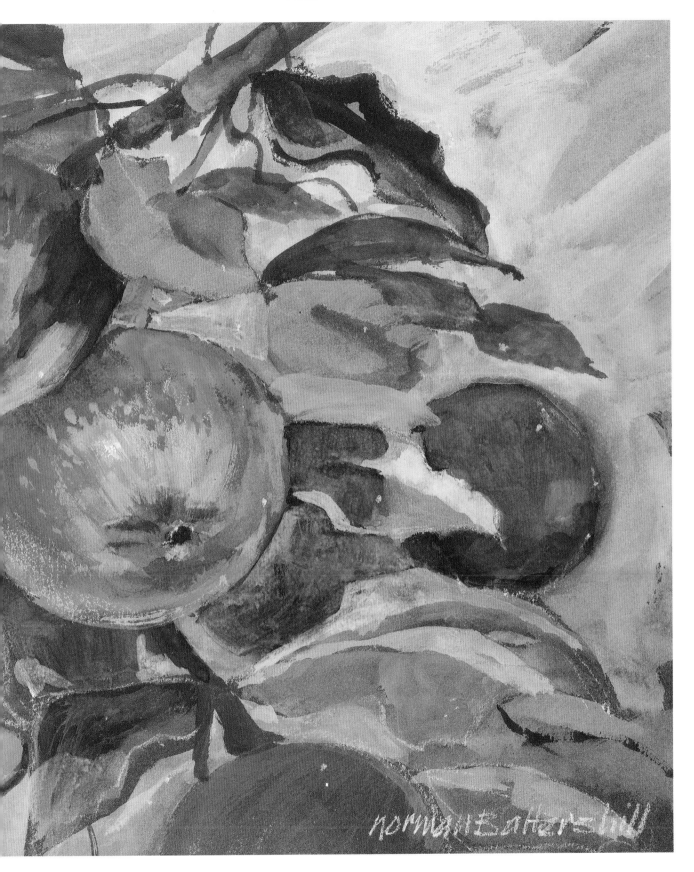

ONIONS IN THE SUN.
Charcoal on smooth white card,
165 × 229 mm (6¼ × 9 in.)

Seeing these onions in a garden shed gave me the idea for this charcoal sketch, so I put them on a table outside in the sun. The big shapes were wonderful – like shining golden minarets. Twisted tops and curling roots contrast with the smoothness of the bulbs and create an interesting composition.

I began by indicating the onions lightly with a piece of thin charcoal. To achieve the smooth effect of the onion skin, I smudged the charcoal and then lifted out parts with a putty eraser. Smooth white card is ideal for this technique.

I left the background until last so that I could judge the tone more easily. I decided on a bold counterchange of light and dark on the left, but a more subtle effect on the right. I have found that the best way to get a solid black with charcoal is to build it up in two or three layers, fixing each one with charcoal fixative.

When the onions are thoroughly dried the stems will be plaited into ropes – that will be another subject to draw. Fruit and vegetables make fascinating still-life subjects and can be arranged with garden tools, a trug, gloves and a trowel, and so on. Painting a still life of vegetables or fruit outdoors reveals a beautiful quality of light, totally different from artificial light indoors.

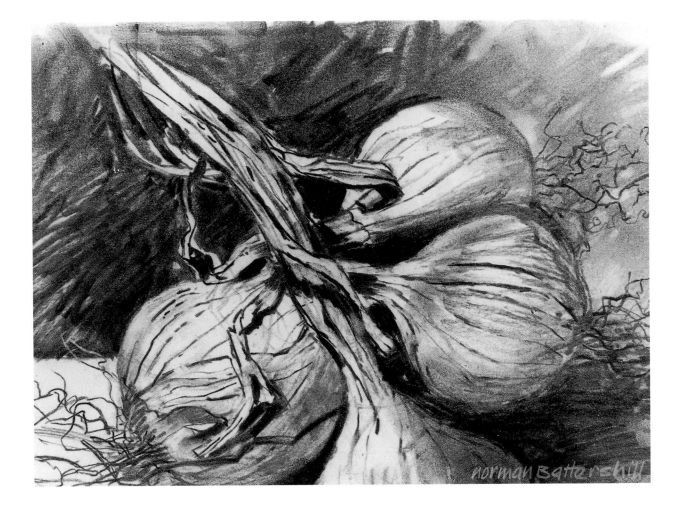

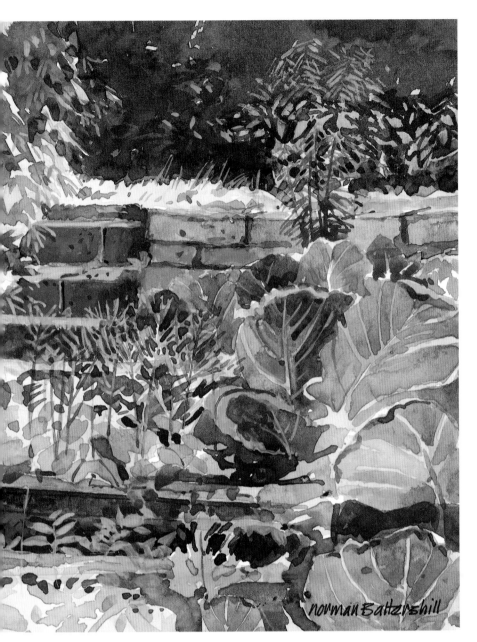

CABBAGES.
Watercolour on hot-pressed, thin white card, 190 × 152 mm (7½ × 6 in.)

I liked this view of the steps down to the vegetable patch. Cabbage leaves are big shapes and create an interesting arrangement of bold patterns. This was a complex subject, even though I simplified it a great deal. In the background there was a low sunlit hedge and a trailer parked in front of it. Although the trailer made an interesting shape, it seemed out of context with the vegetable-garden theme, so I deleted it and changed the background to a hedge in deep shadow to emphasize the sunlit areas.

The inclusion of the wooden battens of the cold frame in the foreground is something I am not happy about, and I feel that I should have deleted them. Having said that, alterations are not always successful, so I decided to leave that part of the painting as it was. The horizontal steps and dry-stone wall are an important counterbalance to the upright cabbage leaves.

The hot-pressed card that I used for this watercolour is quite absorbent, which encourages the direct application of colour. The colours that I used were indigo, Payne's gray, burnt sienna, French ultramarine, alizarin crimson and lemon yellow.

Norman Battershill

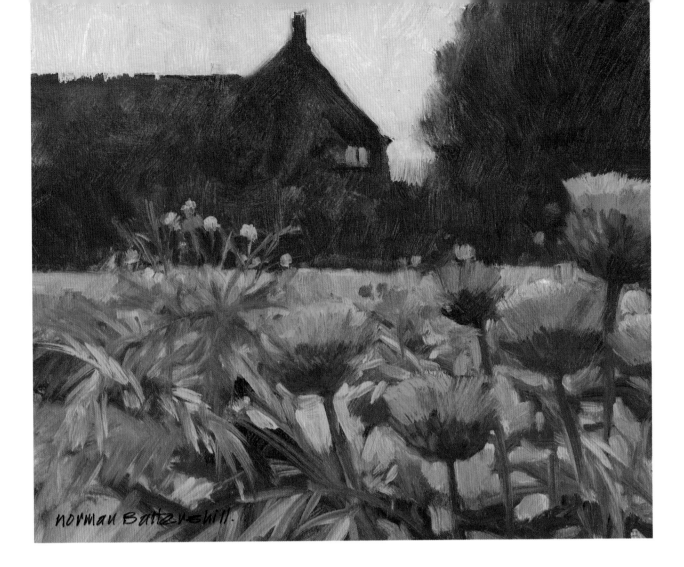

norman Battershill.

(*Opposite*) CORNER OF THE VEGETABLE GARDEN.
Watercolour and charcoal on smooth white card, reproduced actual size

I combined watercolour with charcoal for this mixed-media painting of a corner of a vegetable garden.

With a subject composed of different elements, there are always alternative ideas. There are several parts of this subject which, if separated, would make very interesting paintings in their own right. I can visualize the battered bucket as a full-size painting, for example. A close-up of onions drying on the weathered board would be another possibility. Changing the viewpoint and eye level would offer further potential.

I fixed the initial charcoal drawing before applying watercolour. Once the watercolour had dried, I strengthened the charcoal drawing and then fixed it again. The colours that I used were French ultramarine, cadmium yellow, cadmium red, raw sienna, burnt sienna and sap green.

MORNING LIGHT.
Oil on acrylic-primed Bockingford watercolour paper, 210 × 241 mm (8¼ × 9½ in.)

The spiky grey-green foliage and beautiful purple flower of the globe artichoke make a bold decorative feature for the home and also the vegetable garden. I endeavoured to capture the atmosphere of early morning in this painting.

The colours that I used were French ultramarine, alizarin crimson, cadmium yellow, yellow ochre and titanium white.

GARDEN CENTRES

The astonishing variety of subjects to paint at garden centres, including hanging baskets, heathers, alpines, cacti, trees, shrubs, garden ornaments, herbs, bonsai and water gardens, never ceases to surprise me. As well as the big commercial enterprises, small, privately owned garden centres are certainly worth visiting. Some are sadly neglected, with the glasshouses falling into ruin, but these subjects are exciting. I have never yet failed to find a subject to paint at a garden centre.

The structure of a glasshouse is complex, particularly when seen from the inside. A basic knowledge of perspective is an advantage with a subject like this. Absolute accuracy is not essential, but your drawing or painting should look convincing.

Derelict greenhouses have always fascinated me, particularly the old-fashioned, wooden type. I found one of these in Sussex some time ago. Most of the glass was broken or missing, the weather-bleached door hung askew on rusted hinges and weeds were growing through the floor. I completed several paintings of this abandoned and derelict greenhouse and never lost my enthusiasm for the subject. I went back again recently, hoping to paint another picture, but, sadly, it had gone. In its place stood a vast glasshouse the size of a football pitch.

Hanging baskets are popular, and many garden centres now specialize in this market. At the height of the flowering season, hundreds of hanging baskets are filled with a profusion of wonderful colours. Begonias, 'busy Lizzie',

(Opposite)
GREENHOUSE INTERIOR.
Acrylic on primed hardboard,
381 × 178 mm (15 × 7 in.)

The strong pattern of contrasting leaves against the flagstone floor and wall is the main attraction of this acrylic painting. It is also a study in green.

The green leaves of nature are always harmonious in colour, but the inexperienced artist often has great difficulty in creating a comparable harmony with paint. A wide range of greens can be achieved by experimenting with different blues and yellows. Adding red to the resulting

green makes it a more subtle colour. Any colour with a strong element of red will be sufficient, such as burnt sienna, light red or burnt umber. Used with discretion, black, Payne's gray and indigo will increase the range further. Remember that too much white makes a colour chalky.

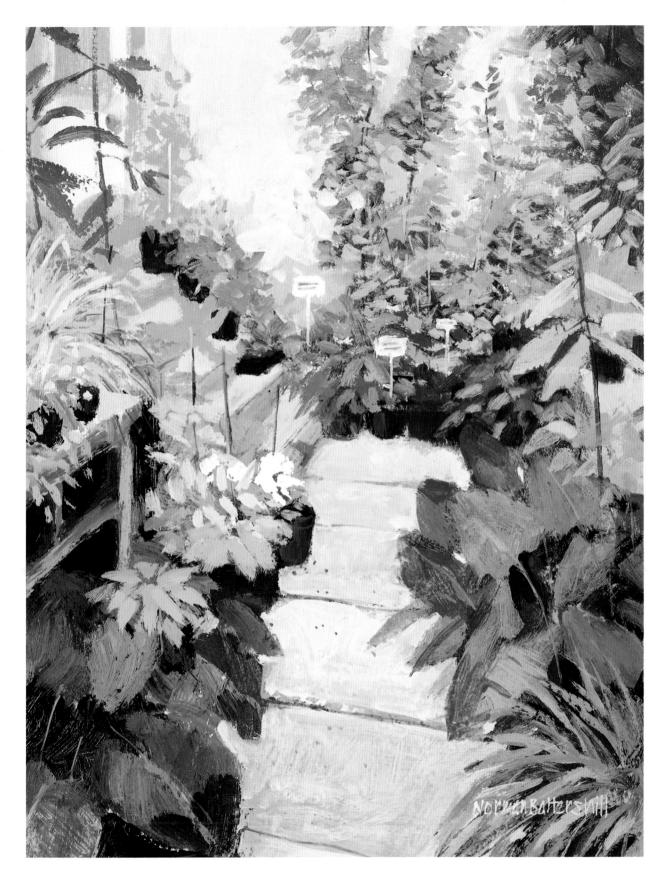

Italian bellflowers, lobelia and pansies fill the glasshouses from one end to the other. Many small garden centres also have hanging-basket displays and are the source for many of my paintings.

Garden centres are heavily populated during the summer months, making it impossible to do any painting, but you may be able to make arrangements to work out of opening hours. Alternatively, taking your own photographs is more convenient and gives you subjects to paint at your leisure and unhindered at home.

It is courteous to ask whether you may take photographs, or do some sketching. I have always received permission in a friendly way. If there are areas where 'no entry' signs are displayed, they should be respected. It should be noted that in some places a permit is required for a tripod or easel. I need hardly make a reminder that trees and plants must not be damaged, and that paint rags and rubbish should be taken away when you leave the site.

As well as glasshouses, almost all garden centres have many other areas of particular interest. Flowers and plants are not confined to inside, and outdoor shrubs, plants and trees are displayed in specific groups. Rows of bedding plants on raised benches create a different viewpoint. Invariably, there will be displays of garden urns and pots in a variety of shapes and sizes. There is great potential here for painting.

Statuary is a feature at many garden centres, ranging from classical figures and Roman columns to an assortment of stone animals. Garden gnomes are always to be found, their jolly smiles guaranteed to add cheer to any garden. Driving through a Dorset village, I came across a sign 'Ideal Gnome Exhibition'. It was worthwhile stopping in response to this droll display of humour, and I was not disappointed. A vast family of gnomes spilled from the barn on to the yard. Some were fishing, but most were idle and just sitting.

If you look around the grounds of a garden centre, you will always find a contrasting variety of related subjects: old barns, sheds, tractors (some rusted and abandoned), vans and an assortment of garden materials. The small, privately owned cottage-industry garden centres are wonderful places for finding homely subjects.

I wonder how many countless gardens have a plaque bearing the words:

> The kiss of the sun for pardon,
> The song of the birds for mirth,
> One is nearer God's heart in a garden
> Than anywhere else on Earth.

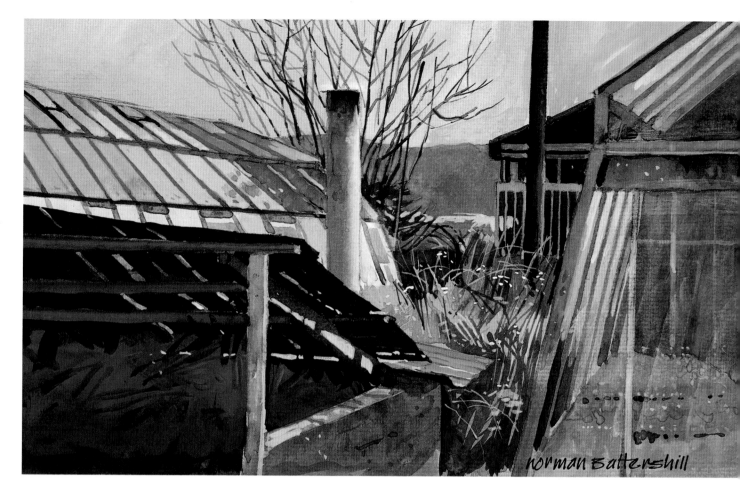

norman Battershill

GREENHOUSES.
Watercolour and gouache on green-brown pastel paper, 178 × 254 mm (7 × 10 in.)

This studio painting shows part of a delightful rural garden centre in Dorset which I frequently visit. I came across this subject one late afternoon while wandering round the perimeter of the grounds. Unfortunately I did not have time for a painting, so I took a photograph and made a charcoal sketch as well.

I was fascinated by the effect of light and shadow in the foreground and the complexity of angular shapes. I emphasized the verticals to counterbalance the forceful angles. The winter tree softens the starkness of the chimney and takes interest into the distance. Although it was cloudy, I decided on a flat sky to create a visual 'rest' from the other areas of the composition. The warm, green-brown colour of the paper showing through the thin washes makes a pleasant unifying harmony.

I established all the darker tones first with a mixture of cadmium red and French ultramarine. I then laid a pale blue wash over the glasshouses to give a ground on which to work. When this had dried, I painted over it with translucent gouache (you can see this effect on the right-hand side). I mixed poster white with the watercolours to produce the gouache. The final touches were the spots of wildflowers and the sunlight and shadow in the foreground.

The colours that I used were French ultramarine, cobalt blue, burnt sienna, cadmium red, cadmium yellow and raw sienna.

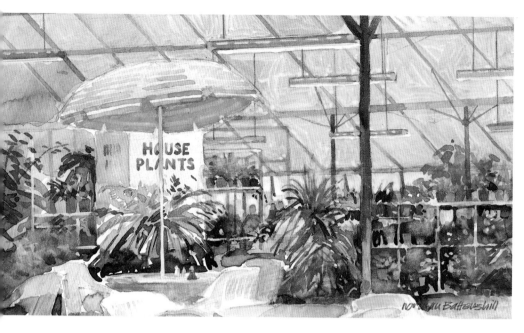

GARDEN–CENTRE CAFÉ.
Watercolour on smooth white card,
127 × 216 mm (5 × 8½ in.)

While I was having a cup of tea at this garden-centre café I took a photograph of the setting, and completed this watercolour in the studio later. The café was crowded, so I simplified the photograph and left out the people seated at the tables in the foreground. (As I cannot paint figures at all well I prefer not to include them – particularly close-up!)

The structure of the glasshouse and the sense of space created by natural light through glass make an interesting atmospheric subject. To achieve this effect, I first laid a wash of pale French ultramarine over the roof area. When this had dried, I painted over it with a translucent wash of process white.

The shapes of the table and chairs seemed too dominant, so I wiped them out and left just the stain of colour to give the impression of soft light in the foreground. I kept the vinegar bottle and the salt and pepper pots on the table in the background. This small detail counterbalances the emptiness of the foreground.

The watercolours that I used were French ultramarine, Payne's gray, cadmium yellow and cadmium red, and also process white.

GARDEN CENTRE, DORSET.
Charcoal pencil and white
pastel on grey pastel paper,
231 × 330 mm (9 × 13½ in.)

My sketch here shows another part of the garden centre illustrated on page 71. I found this interesting subject at the

back of the greenhouses. The polythene tunnel and the strong verticals of the open shed lead into the rural landscape beyond.

I have tried to give an impression of the texture of the countryside and a feeling of recession into the distance.

The tree was on the right-hand edge of the composition, but I moved it further to the left to break up the heavy structure of the open shed. I also simplified the pile of flowerpots on the right.

My sketch consists of three tones: black (charcoal pencil), white (pastel), and the middle tone of the paper. This combination is ideal for rendering tonal values quickly, either as a rough sketch or a more finished drawing.

(Below) PLANT STUDY.
Watercolour on deep buff pastel paper, 178 × 254 mm (7 × 10 in.)

There is not a great deal of merit in this subject, but the varied pattern of leaves attracted me to the simple composition. The old water tank filled with gravel against the wall creates an interesting arrangement of angles which lead into the painting.

After drawing in the general shapes, I painted the light colours of the leaves and tank. I put in the dark background of Payne's gray fading off into raw sienna to establish the tone of the leaves on the lower right. I mixed burnt sienna and cadmium yellow for the brown leaves, and used the same colour for the brick capping to the wall. I mixed a touch of raw sienna with process white so that the top edge of the tank would show up in contrast.

Wandering around the back of greenhouses at garden centres always produces a great variety of subjects to paint, but it is courteous to seek permission first before going beyond any boundaries. The watercolours that I used for this study were Payne's gray, cadmium yellow, burnt sienna and raw sienna, and also process white.

(Opposite)
GREENHOUSE INTERIOR.
Gouache on pale blue-green pastel paper, 190 × 165 mm (7½ × 6½ in.)

Draped polythene in a greenhouse gave me the idea for this gouache painting. I would like to have spent more time on it, but my rough sketch has the potential for a studio painting later on.

I roughed out the subject with a soft pencil and established a vanishing point as a guide for the perspective. I used diluted process white with a touch of raw sienna and French ultramarine for the effect of the draped polythene, and painted over the background.

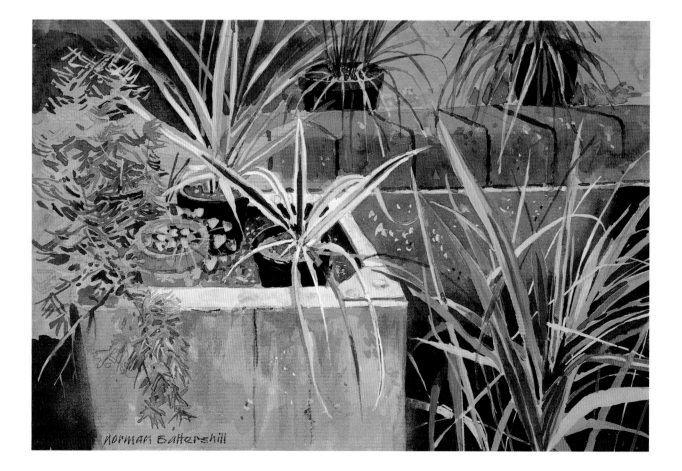

The other colours that I used were cadmium yellow and cadmium red.

(Below)
AFTER THE HURRICANE.
Charcoal pencil on Bockingford watercolour paper, 77 × 194 mm (3¼ × 7¾ in.)

The great storm of October 1987 in southern England destroyed thousands of trees and caused extensive damage to countless properties. At Kew Gardens, five hundred specimen trees were brought down and many others were damaged. Greenhouses caught in the storm were flattened like packs of cards. Unfortunately, some garden centres and commercial growers never recovered from the disastrous loss.

I found this abandoned, storm-battered greenhouse in Sussex recently, and made a drawing as a reminder of the 1987 devastation. I chose charcoal pencil as it seemed appropriate to the subject.

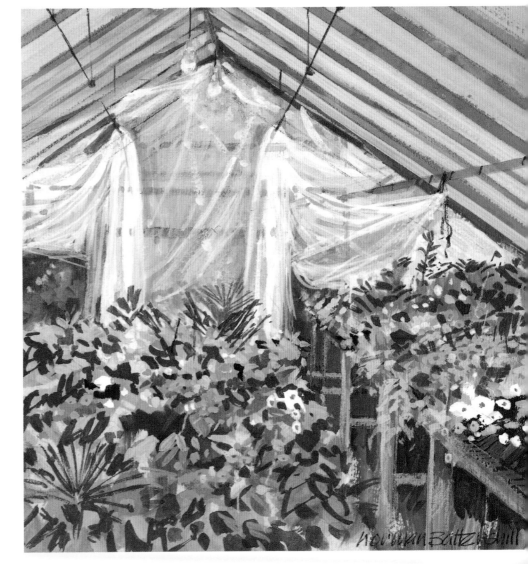

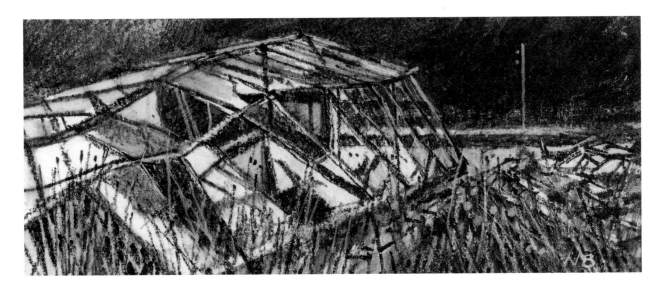

WATERLILIES.
Oil on primed white card,
165 × 229 mm (6½ × 9 in.)

For this oil painting I used a reference of a water-garden centre and created an imaginary garden setting from it. On my studio wall I have two treasured photographs of Monet in his studio at Giverny with his big waterlily paintings.

These canvases were so big that he had to build a vast new studio in which to work. It is impossible not to visualize his masterpieces when painting a similar subject of your own.

I endeavoured to create mood and atmosphere in this small oil painting. Although the subject is actually almost all green, I avoided using this colour. The colours that I did use were alizarin crimson, cadmium red, raw sienna, cobalt blue, French ultramarine and titanium white.

I primed the white card with gesso primer, and when it was dry washed over a stain of French ultramarine and cadmium red. The diluted colour soon dried, so I was quickly able to establish the dark group of trees and their

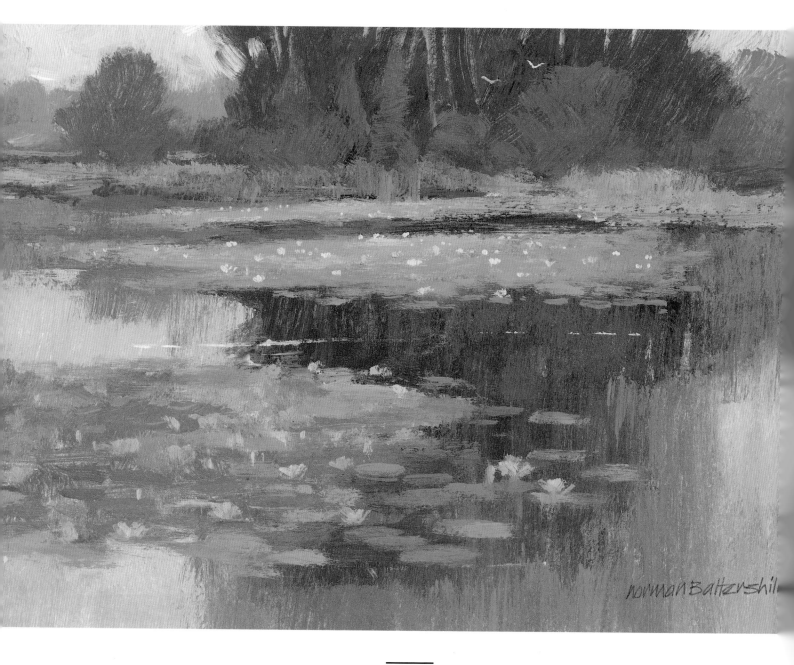

norman Battershil

reflections. For the sky I mixed white with raw sienna and a touch of cobalt blue. I darkened this colour slightly for the reflection.

Too much definition of the lilypad rafts would have lessened the atmospheric effect that I wanted. By simplifying the waterlily leaves and flowers, harmony was established with the big shapes in the background.

My painting is quite small, but to keep the brushwork broad I used only two brushes, a well-worn no. 10 hog bristle and a small synthetic brush for the touches of detail. I think the painting has the potential for a large painting later on, although quite often a small painting loses impact when reproduced on a larger scale.

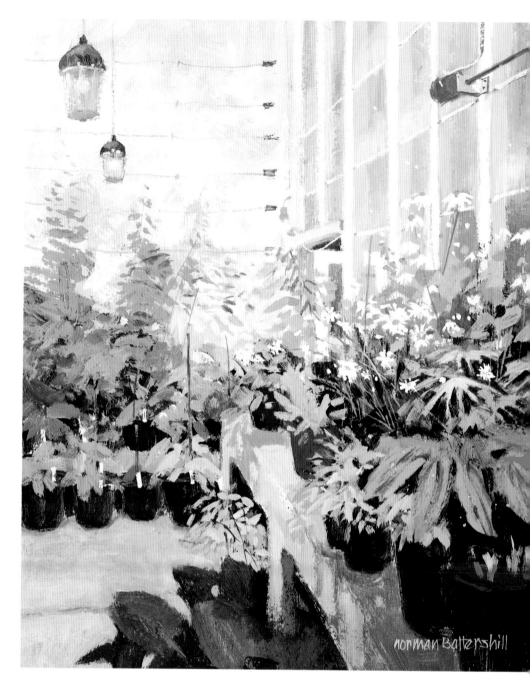

FORDE ABBEY GLASSHOUSE. *Acrylic on primed hardboard (Masonite), 381 × 178 mm (15 × 7 in.)*

This painting shows a small part of an old glasshouse. A vertical format suited the subject, because I wanted to include the lights and the support wires across the wall. The proportion also helps to emphasize height and space.

I painted this picture in acrylic, so I worked in the same way that I do for oil by establishing the darks first. I then applied a pale wash of French ultramarine and cadmium red with white to the wall and stone floor, as an overall tone on which to work.

After putting in the vertical supports on the right, I painted between each one with dark blue. When the colour was completely dry, I painted over it with a translucent wash of white with a slight touch of raw sienna to suggest an effect of glass.

For the black pots I mixed cadmium red and French ultramarine without any white added. This combination makes a very powerful, dark colour that I much prefer to black. The red tags are a foil to the predominance of green in the painting.

POTTING SHED.
Oil on acrylic-primed Bockingford watercolour paper, 279 × 141 mm (11 × 5½ in.)

Changing what was a horizontal format to a narrow vertical format made this subject much more interesting. The main interest is the view through the door opening, and this is what I have focused on. I was particularly attracted by the pale, diffused light from the glass roof and the way that it softens the greenery of plants on the staging. I also liked the strong element of design formed by verticals, angles and horizontals.

The greenhouse joined on to a lean-to shed with a corrugated-iron roof. This and the dark, solid structure of the end wall helped to emphasize the effect of light through the glass roof. A strong counterchange of light and dark always adds impact and interest to a painting.

Another aspect that appealed to me in this subject was the way in which nature had taken over the floor with flourishing weeds. Even the step had weeds growing up through it, preventing the sliding door from ever being closed. The colours that I used were French ultramarine, cadmium yellow, cobalt blue, cadmium red and titanium white.

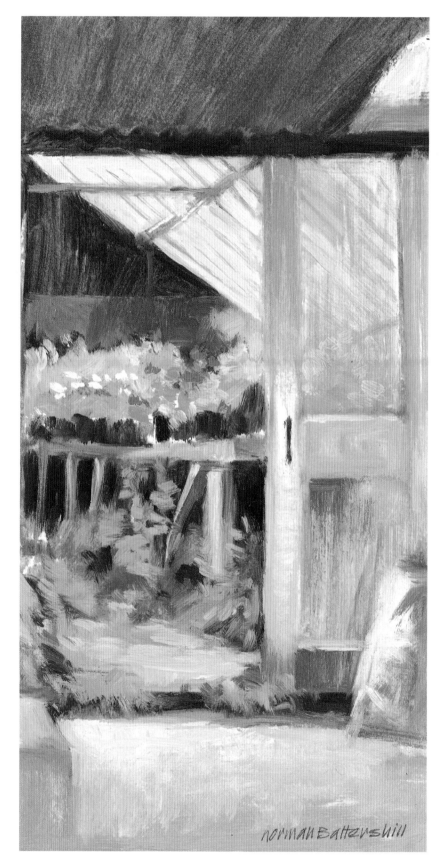

GARDENS OPEN TO THE PUBLIC

The number of gardens open to the public in the British Isles alone exceeds five thousand. Over three thousand of these are privately owned. Private owners first opened their gardens for the National Gardens Scheme in 1927, for the benefit of the nursing profession. Every year these gardens offer enjoyment to the public with the benefits going to deserving charities through the National Gardens Scheme. Here is a wonderful opportunity to visit a great variety of much-loved gardens with perhaps the chance of being able to paint. Permission for this privilege must of course be granted by the owner. The National Gardens Scheme publishes a handbook with a list of gardens open to the public, and you can find their address on page 126.

As well as these gardens open to the public, there are also royal botanic gardens, gardens of stately homes and historic houses, water gardens, specialist gardens of unusual and interesting plants, and many more. Some years ago I was very privileged to hold the first residential painting course in Windsor Great Park. The tranquil and unspoilt environment will long be remembered. Just a short distance away are the beautiful Savill and Valley Gardens, where fifty acres are devoted to the largest planting of

rhododendron species in the world. Permission to paint there must be obtained from the Keeper of the Gardens.

The magnificent Royal Botanic Gardens at Kew in Surrey contain the world's finest collection of plants. If you visit Kew, be sure to see the 832 paintings by the intrepid Victorian traveller, Marianne North, and the beautiful botanical prints by Margaret Mee. The Royal Botanic Garden in Edinburgh, Scotland, dates back to 1670 and is the second-oldest botanic garden in Britain. The oldest, founded in 1621, is the botanic garden at Oxford.

More than a hundred gardens and two hundred historic buildings open to the public are listed in the National Trust Handbook. Some gardens are open all year, making it more convenient to paint when the summer visitors have gone.

I have already mentioned that permission is required for a tripod or easel. As a more convenient alternative I use my pochade, but there are some areas of gardens open to the public where even a pochade is impractical. A sketch is often sufficient to use as a reference for studio painting. Taking photographs without the use of a tripod is the quickest and easiest way to collect reference material. Painting

from your own photographs is preferable to working from photographs taken by someone else, as the subject matter and composition will be of your personal choice.

All the illustrations in this book represent only a small example of the tremendous potential awaiting you in countless lovely gardens.

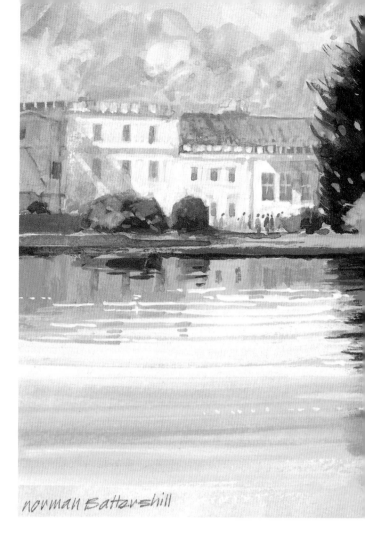

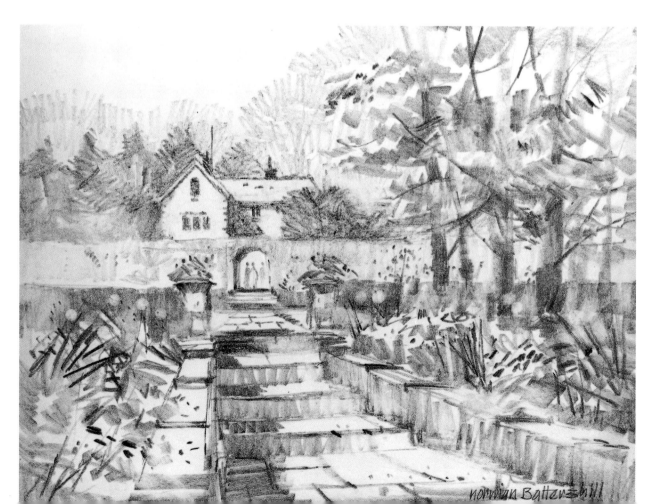

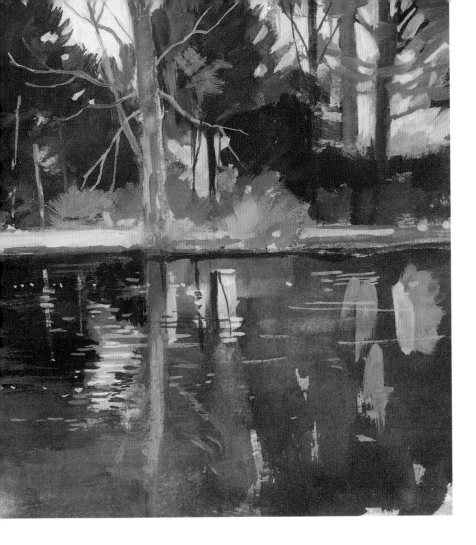

FORDE ABBEY, DORSET.
*Gouache on Cotman 140 lb
(300 gsm) watercolour paper,
178 × 279 mm (7 × 11 in.)*

Set in the heart of the Dorset countryside, Forde Abbey has its origins in the early eighteenth century. Thirty acres of landscaped gardens surround this beautiful Cistercian monastic building. Wherever you walk there is an abundance of subjects: magnificent shrubs and trees, flower borders and lakes, and a splendid kitchen garden. At any time of the year there is always something to interest the artist.

I was attracted by the counterchange of dark against light in this scene. The rich colour of evergreen trees contrasted with the pale honey colour of the stonework and reflected into the placid lake. The advantage of gouache is that it enables one to paint from dark to light in the manner of oils.

I began by establishing the trees and reflections. The colours that I used were French ultramarine, alizarin crimson, lemon yellow, burnt sienna, yellow ochre and white. I simplified the painting a great deal and retained only the essential shapes.

(Opposite) SUMMER GARDEN.
*Soft pencil on cartridge paper,
184 × 235 mm (7¼ × 9¼ in.)*

A terraced garden has several levels offering alternative subjects. My pencil sketch of a formal garden in the grounds of a historic house shows only one of the many viewpoints that I found. I particularly liked the arched opening in the evergreen hedge and the group of people beyond. The afternoon light was soft, but strong enough to cast shadows that show form and a contrast of tone values.

I have endeavoured to give an impression of place and atmosphere. The borders flanking the steps were profuse with flowers, but I simplified them to keep the drawing broad. The pencil that I used for this sketch was a soft carpenter's pencil, which has a chisel-shaped lead.

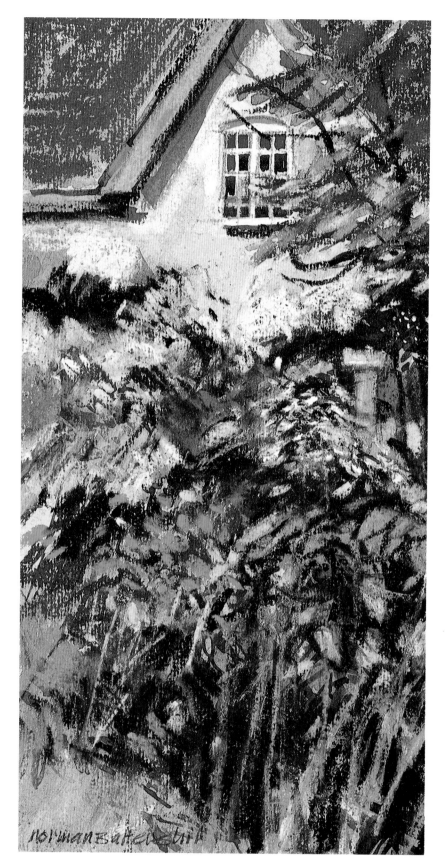

(Left) CORNER OF A GARDEN.
Pastel on blue-green pastel paper,
231 × 119 mm (9 × 4¾ in.)

This pastel sketch shows a small
part of a beautiful private
garden open to the public in
aid of the National Gardens
Scheme. I was full of
admiration for this delightful
setting, and know that the
owners spend many long hours
of devoted work in creating an
oasis of colour and form.

This garden is one of over
2,600 gardens in England and
Wales open to the public at
specific dates in aid of the
Scheme. The owners were
only too pleased to give me
permission to do some painting
in their lovely garden, and
kindly gave me a a welcome
cup of tea.

My painting began as a watercolour sketch heightened with white on blue-green pastel paper. As the garden suddenly became busy with visitors, however, I thought that it would be better to finish the painting at home. Back in the studio I decided to complete it as a pastel sketch, while the subject was still fresh in my mind. There is probably a good deal that I have left out, but it is sufficient to remind me of one of the most pleasant afternoons I have had in a garden.

(Below)
BATEMANS, EAST SUSSEX.
Acrylic on Bockingford watercolour paper, reproduced actual size

Rudyard Kipling designed and planted his rose garden, now in the care of the National Trust, when he lived at Batemans in East Sussex from 1902–36. He incorporated a large pond with a narrow channel to feed the rose garden's fountain, and his layout remains the same today.

When I lived in Sussex I made many visits to these enchanting gardens with their yew hedges, lawns, terraces, and screen of pleached limes bordering the pond. From the secluded seat in the shaped hedge, the view toward the pond and rose garden is tranquil and calming to the spirit. For me it is typical of an English formal garden.

I have endeavoured to capture this impression in the acrylic painting below. It is only a small part of the setting, but includes the essential features. The hedge is very much a positive outline, but I 'lost' some of its edges to prevent the shape from being too pronounced. I also emphasized the channel in the foreground to make a link with the severe line of the hedge.

The colours that I used were French ultramarine, cadmium red, cadmium yellow, cobalt blue and titanium white.

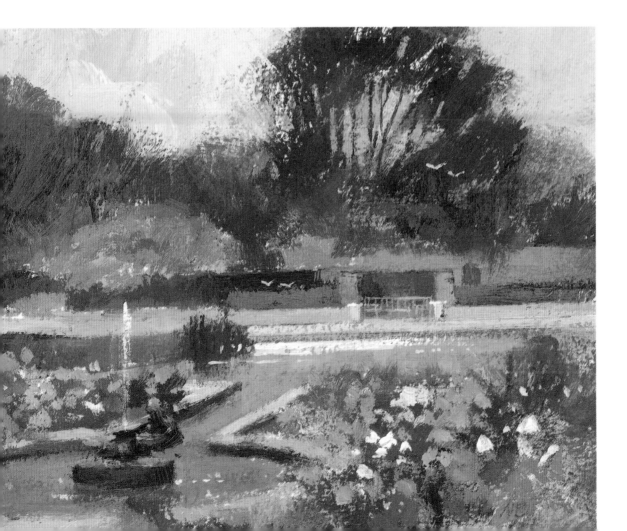

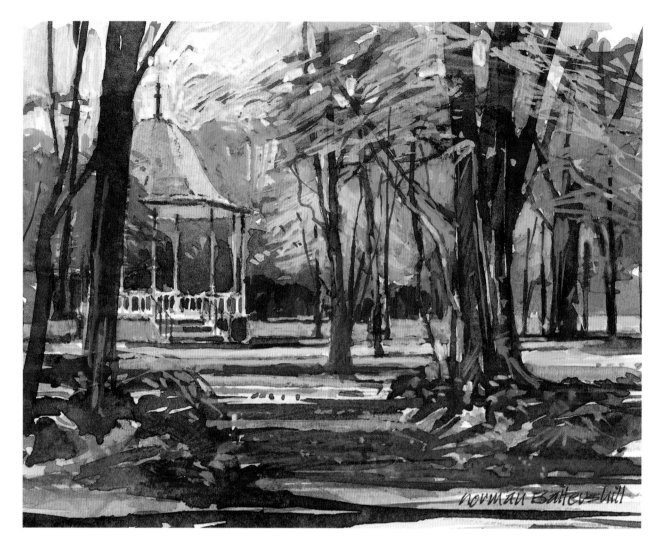

BANDSTAND.
*Watercolour and gouache on
Bockingford watercolour paper,
150 × 178 mm (5¾ × 7 in.)*

An elegant bandstand in a
municipal public garden gave
me the idea for this gouache
sketch. The simplicity of the
structure and its delightfully
shaped roof seem to relate to
the trees surrounding it.

I wonder when the
bandstand was last filled with
colourful uniformed figures
playing jolly music to the
summer crowds. Such occasions
are, unfortunately, now very
rare. To create the effect of
this silence, I decided not to
include the people who were
there. I began my sketch in
watercolour, and then added
gouache to give more strength.

Municipal gardens often have
an architectural feature such as
a bandstand or monument.
Some have small but interesting
Victorian buildings and perhaps
an ornamental clock tower.
Having the resources of their
own gardeners and facilities for
growing plants and shrubs,
these gardens are generally well
cared for. Town and coastal
gardens in the summer season
are bright with colourful
flower borders, and should not
be missed as subjects to sketch
and paint.

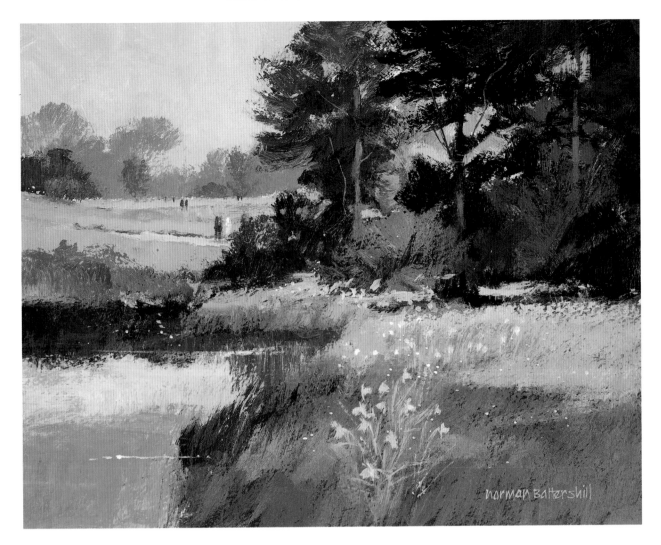

SPRING.
Acrylic on watercolour paper,
229 × 279 mm (9 × 11 in.)

The gardens of large estates often extend into the surrounding countryside to become part of the natural landscape. My studio painting is an example of this. I chose a viewpoint by the pond, as it gave me the opportunity for a landscape subject.

It was springtime and the ground in front of me was a mass of daffodils. To fit in with my composition I simplified these into a curving line, leading into the groups of trees and linking up to the path beyond. I did not continue the direction of the path because it would have taken interest out of the picture. Instead, I placed two figures in the middle distance to create the effect of further recession. Trees in the background complete the illusion of depth and space.

The finer points of the composition were not planned beforehand, but developed as the painting progressed. I used only three colours for this acrylic painting: lemon yellow, red iron oxide and French ultramarine, and also titanium white.

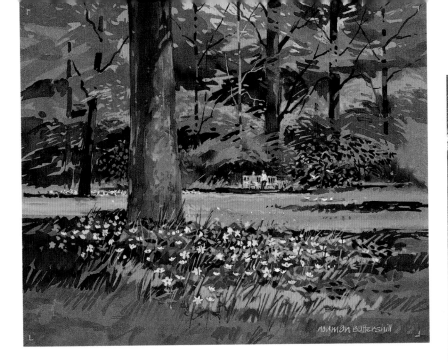

(Above) SPRING.
Watercolour and gouache on grey pastel paper, 203 × 254 mm (8 × 10 in.)

(Right) CYPRESS GARDENS, CHARLESTON, USA.
Oil on canvas, reproduced actual size

This tranquil spring setting is part of a beautiful abbey garden. The grey pastel paper that I used for my watercolour is an excellent middle tone, and this warm tint showing through harmonizes all the various greens.

For the daffodils I added a touch of white to cadmium yellow. Instead of French ultramarine, I used indigo for mixing with lemon yellow and yellow ochre for green. A touch of alizarin crimson modified the green to a subtle colour.

I put the sky in last with a mixture of indigo and a little white. I also used white for the seat and the doves. Neither were actually there, but I added them to give scale, distance and movement. Apart from using gouache for these small areas, the painting is pure watercolour.

This book would not be complete without reference to the magnificent trio of celebrated gardens in the southern states of America.

Middleton Place was the first garden in America to be designed and created as a landscaped garden. The work began in 1741 and continued for almost ten years. Since then, generations of the Middleton family have devoted their attention to maintaining and developing this famous garden.

Magnolia Gardens, also on the Ashley River, were created in the 1830s and designed by the Reverend John Grimke Drayton. The natural setting of swamp cypress trees and groves of wild oak trees festooned with Spanish moss are used as a backdrop to masses of bright azaleas. Magnolia Gardens are abundant with a great variety

of shrubs and flowers which delight the annual thousands of visitors.

Cypress Gardens are the last of the trio. These dramatic gardens were created in 1927 from a lake hidden in a vast cypress forest. Today you can see the gardens from a boat, drifting along the channels in

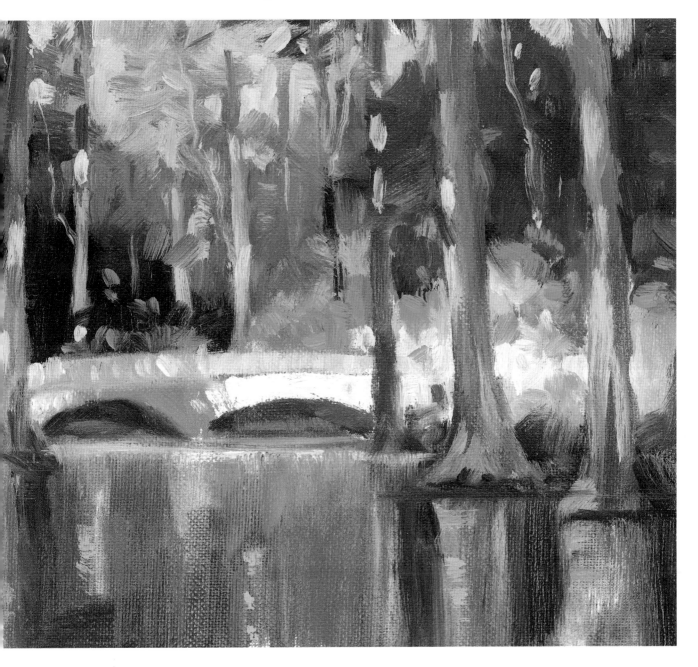

the wonderful setting of cypress trees and banks of brilliant flowers and exotic birds. What a paradise these gardens must be for the artist.

The painting above is of the Cypress Gardens. I have not had the good fortune to visit Charleston, and therefore had to use a black-and-white photograph as a reference. From this I created my impression of the colour and splendour of a setting in the near-tropical environment of the Cypress Gardens.

I included the bridge as a necessary counterbalance to the strong vertical element of the composition. The bright colours of the flowering shrubs also create a contrasting balance. The oil colours that I used were French ultramarine, cobalt blue, cadmium orange, alizarin crimson, cadmium red, cadmium lemon and titanium white.

(Above)
OXFORD BOTANIC GARDEN.
Charcoal on smooth white card,
152 × 254 mm (6 × 10 in.)

My charcoal sketch shows a
small part of the Oxford
Botanic Garden – the first
physic garden to be established
in Britain. In 1621 a substantial
grant of five thousand pounds
was given to the University by
Henry Davers for the purpose
of growing medicinal herbs
to advance the faculty of
medicine. The University
Botanic Garden has the
valuable role of supplying plant
material to the University for
the study of botany and

biology. It is also a source for research not only at the University but at colleges and schools as well.

In its delightful riverside setting of walled gardens, there is a comprehensive collection of more than eight thousand species and varieties of plants. Glasshouses feature ferns, tropical lilies, orchids, palms and succulents. For its size, this compact and historic University Botanic Garden offers much scope to a painter of gardens.

(Opposite, below)
GARDEN IN A TENT.
Gouache on Bockingford watercolour paper, 95 × 119 mm ($3\frac{3}{4}$ × $4\frac{3}{4}$ in.)

Flower shows and garden festivals attract thousands of garden lovers. The world-famous Chelsea Flower Show in London displays a huge variety of flowers, shrubs and trees, in dream gardens cleverly created in pocket-sized spaces in a marquee and outside.

International garden exhibitions organized by host cities also provide wonderful opportunities for the garden painter. The crowds invariably make painting impossible, however, so a photograph is usually the only way to collect garden subjects. This gouache painting is an example of a colourful tiny garden created in a flower-show tent.

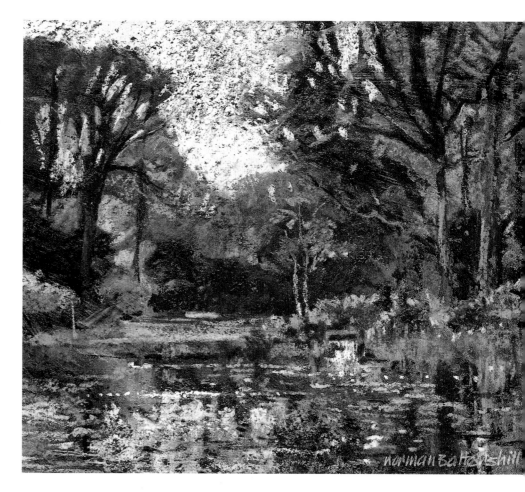

(Above) SAVILL GARDENS, WINDSOR GREAT PARK.
Pastel on cartridge paper, 196 × 231 mm ($7\frac{3}{4}$ × 9 in.)

The Savill and Valley Gardens are set in the four-and-a-half thousand acres of Windsor Great Park, and are a paradise for artists. For this pastel painting I selected a very small area of the gardens, where the stream enters the upper pond.

During May the banks are bright with the colours of azaleas and are the main attraction for the countless visitors, I wished to capture an atmosphere of solitude for my painting, however, so I chose

the winter season, when tone values were rich and strong. Creating mood in a painting may mean disregarding a more popular version of the subject, but in doing so you will discover the true spirit of the setting, as I hope I have done in this painting.

I must once again add the reminder that permission to paint or sketch must always be obtained from the Keeper of the gardens.

GLASSHOUSES

The interiors of glasshouses have great subject potential, but seem to be overlooked by the majority of artists. Natural light passing through an expanse of glass has a unique effect that is soft and silvery. Even in a small domestic greenhouse, the quality of light evokes a feeling of serenity. Take note of the wonderful atmosphere the next time you go into a glasshouse.

During the flowering season, the glasshouses at garden centres are packed with a variety of bright bedding plants in rows of trays on benches. Here is a subject to delight the artist who likes to paint masses of flowers. The interior of a glasshouse is a favourite subject of mine. As well as the interesting structure itself, there are always plenty of subjects to paint inside.

Many of the elegant Victorian and Edwardian domestic glasshouses and conservatories are sadly no longer in existence. If you happen to find one, do not miss the opportunity to make a sketch or take a photograph. The interiors of these lovely structures are examples of an era when attention was given to the design of even the smallest details, such as locks, latches, stress bars, finials and capping, and the pattern of floor tiles.

An impressive example of a Victorian glasshouse is the palm house at the Royal Botanic Gardens at Kew in Surrey (see pages 100–1). This dramatic centrepiece to the gardens was constructed between 1844 and 1848, and was designed to house tropical plants and palm trees. As a young boy I lived near Kew Gardens and remember lovely summer days when my parents took me to this magical setting by the River Thames. It was an historic time, because I had the pleasure of going into the magnificent palm house before it was completely dismantled and rebuilt between 1984 and 1989, using most of the original materials and specifications. Today, this remarkable jelly-mould structure is a classic example of Victorian design. The humid atmosphere of the interior and the lush vegetation create the illusion of being in a tropical clime.

The tropical and temperate palm houses at the Royal Botanic Garden in Edinburgh are also elegant examples of the same era. These, too, are wonderful glasshouses containing a rich variety of plants and trees that create the illusion of an exotic landscape. The glasshouses of botanic gardens offer a wonderful source of unusual subjects, but remember that you must obtain permission to use an easel or tripod.

GLASSHOUSES AND POLYTHENE TUNNEL.
Oil on acrylic-primed watercolour paper, 254 × 152 mm (10 × 6 in.)

I could not have wished for a more interesting subject than this. The light was just right, emphasizing the bold shapes of the glasshouses and polythene tunnel. An old sink, bucket and tap added some bits of detail without being too fussy.

I began my oil painting with a stain of green all over the foreground, and a deep purple stain over the background. This established the principal tone values on which to build the painting. For the polythene tunnel, I first stained it with raw sienna (I retained part of this to the left of the door opening). I painted over the sienna ground colour with opaque white, and then added the stretch marks to the sheeting. The marigolds in the foreground provide some lively spots of colour and add to the effect of sunlight.

I was very lucky with this painting. The subject was good and my painting went right first time from start to finish. The colours that I used were cadmium yellow, cadmium orange, raw sienna, French ultramarine, burnt sienna and titanium white.

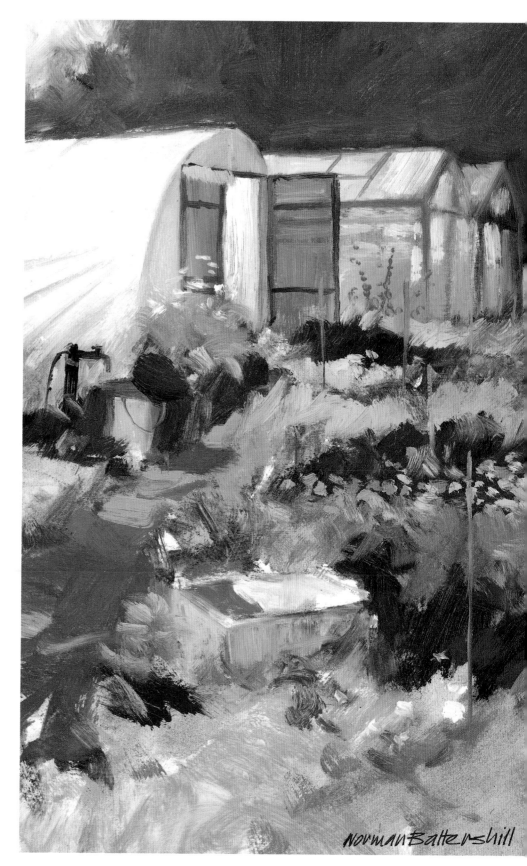

Norman Battershill

A small domestic greenhouse has plenty of subjects if you look for them. A view from the outside looking in through an open door has a number of possibilities. Alternatively, looking through the open door to the garden beyond is well worth considering. Getting the perspective of the interior to look right is essential. I always mark the position of the eye level and vanishing point. If the interior view is complex, I rough out the structure and perspective in charcoal or pencil so that it is reasonably accurate. Trying to correct faulty perspective later on in a painting invariably entails major alterations, with the prospect of doomed failure.

I have found some of the most interesting subjects in glasshouses situated in country areas. Quite often there is not the tidiness usually found in the bigger and more commercial glasshouses, and I like the informality and character of these rural places.

Suggesting the effect of daylight through the roof of a glasshouse interior is not easy. I retain the white priming of an acrylic or oil painting until the very last stages. A final glaze of translucent or transparent tint will achieve the effect.

Another method that I use is very slow, but the effect justifies the time spent. I paint the sky colour between each roof window, varying the colour and tone very slightly. To achieve an effect of depth, I sometimes make several applications of thinned colour. A much quicker method is to finish the sky first and then to paint the roof structure over it when dry. This is the method I adopt when painting in watercolour.

The various types and sizes of glasshouse and conservatory offer endless scope for those artists who like painting structures and the effect of light.

POTTING OUT.
Watercolour on smooth white card,
241 × 337 mm (9½ × 13¼ in.)

The contrast of textures is really what this subject is about. The green plastic tray is perhaps a bit too dominant, but I think that the brick piers to the right counterbalance it. The angles had to look convincing, so I took some time in drawing the composition, as making

Norman Battershill

drastic alterations once the painting has progressed is not always satisfactory.

I used masking fluid for the reflected light and the lettering on the shiny fertilizer bag. The black flowerpot and darker areas were necessary in this subject to emphasize the effect of light throughout the painting. I mixed the darks from French ultramarine and Payne's gray with a touch of red. Here and there I used touches of gouache on the leaves. I used a carbon pencil for the graining on the wood – and had to stop myself from overdoing it!

Even in this small area of a greenhouse, there were many more viewpoints for further interesting subjects. The watercolours that I used were Payne's gray, French ultramarine, burnt sienna, cadmium red, viridian and yellow ochre.

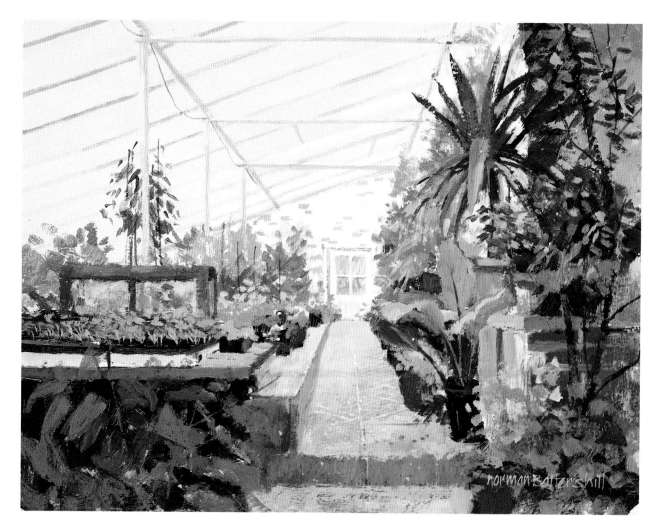

GLASSHOUSE.
*Acrylic on board, 381 × 508 mm
(15 × 20 in.)*

The perspective in this painting is forceful and had to look right, so I set out the vanishing point and converging lines carefully. Having a sound drawing to work on always gives confidence and minimizes the need for alterations later on.

The colour scheme is mostly a variety of greens. Every green in nature has a trace of red in it, and creating harmonious greens in a painting is achieved by adding warm colours such as alizarin crimson, cadmium red, cadmium orange, burnt sienna or burnt umber. I mixed green from blue and yellow, and then added a touch of alizarin crimson. By varying the combination of blues and yellows a wide range of greens can be mixed.

To achieve an effect of translucent light through the whitewashed glass roof, the first step was to cover the whole area with pale blue. When this had dried, I painted on a thin mixture of white and raw sienna and let some of the underneath colour show through.

The walkway was made of stone slabs in the foreground and joined beautifully laid herringbone brick. I was careful not to place too much emphasis on this section. The diagonal lines create an interesting pattern and add texture to the path. The step in the foreground is important, as it creates a bold, horizontal counterbalance to the perspective of the walkway.

The acrylic colours that I used were French ultramarine, cadmium red, burnt sienna,

Payne's gray, cadmium yellow, lemon yellow, alizarin crimson, burnt umber and titanium white. This may seem a long list of colours, but most were used for adding to green.

ABBEY GLASSHOUSE.
Pastel on Ingres paper,
285 × 223 mm (11¼ × 8¾ in.)

I discovered this old glasshouse in the kitchen garden of a seventeenth-century monastery, which is now an elegant home. The crumbling surface of the walls created a delightful texture that seemed ideal for the medium of pastel.

The scaffolding was a more recent addition, to stabilize the large glass roof. Although the poles were painted white, I changed this to suggest a patina of rust, which suited the atmosphere of age in my subject. The vertical poles and dark tone are also an important counterbalance to the acute angles of shelves and the potting bench in the foreground.

Creating a sense of space is an important element of a painting. Here, the window opening in the wall gives the impression of height and the door an indication of depth. The door led into another section of the glasshouse, and to create this effect I emphasized the soft glow of light through the glass panes. A small detail often has importance, and the opportunity to make use of it should not be missed.

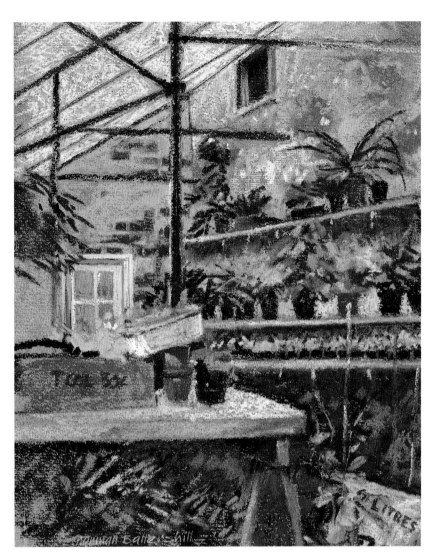

Years and years of humidity combined with lack of cleaning had given the glass roof a delightful translucent patina. I applied grey-blue pastel, and then sprayed it several times with charcoal fixative to give a new textured surface. When it had dried thoroughly I worked over the top with light yellow ochre, but left some of the undercolour showing through. This effect is similar to the scumbling technique of other media. The young seedlings on the shelf make a delightful contrast to the ageing glasshouse. I wonder how many plants have been raised and nurtured in the past by the monks of this Cistercian monastery.

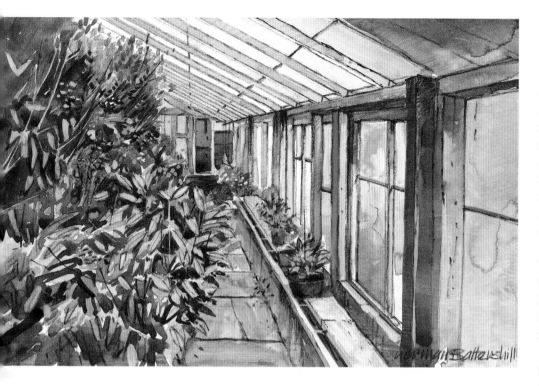

PERSPECTIVE IN A GLASSHOUSE.
Watercolour and carbon pencil on smooth white card, 178 × 279 mm (7 × 11 in.)

An old wooden glasshouse has the timeless atmosphere of tranquillity generated by the growing of plants and flowers over many decades. As soon as I entered this greenhouse I was entranced by the atmosphere and quality of light.

My interest was really in the structure and the perspective of the interior, so I established a vanishing point and did a careful drawing first. I used smooth white card for the watercolour. This is ideal for direct painting, but too much wiping out destroys the surface. This disadvantage can be used to good effect because it encourages a more direct approach.

The glazing bars to the roof were dark, but I decided on a lighter tone to suggest the effect of natural light coming through glass. Adjusting tone values is a constant process when developing a painting.

When the watercolour had dried, I strengthened the structural drawing with a carbon pencil. The colours used were French ultramarine, cadmium red deep, alizarin crimson, raw sienna, burnt sienna and cadmium yellow.

(Opposite)
TROPICAL HOUSE, ROYAL BOTANIC GARDEN, EDINBURGH.
Oil on primed paper, 305 × 241 mm (12 × 9½ in.)

This dramatic setting is part of the tropical aquatic house at the Royal Botanic Garden in Edinburgh, Scotland. Like others in the United Kingdom, the garden offers wonderful exotic settings to paint or visit. It is part of a worldwide network devoted to botanical and horticultural research. An important aspect of this much-valued work involves rescuing plants from final extinction and the conservation of flora.

The gigantic leaves of the Victorian waterlilies lead into the painting. I would like to have included the beautiful creamy flowers, but they had not yet appeared.

I exaggerated the upward growth of the papyrus leaves slightly, to emphasize the height of this dramatic contemporary planthouse. The external suspension pylons were clearly visible through the glass, but, as they detracted from the sense of height I wanted to achieve in the painting, I decided not to define the structure too much.

I added very little white for the dense, rich greens. The brushwork was bold to match the vigorous shapes and growth of these magnificent plants. For the greater part of my painting I used only three colours: French ultramarine, cadmium red and cadmium lemon, plus titanium white. In the final stages I added these extra colours: cadmium orange, cobalt violet dark and cobalt blue.

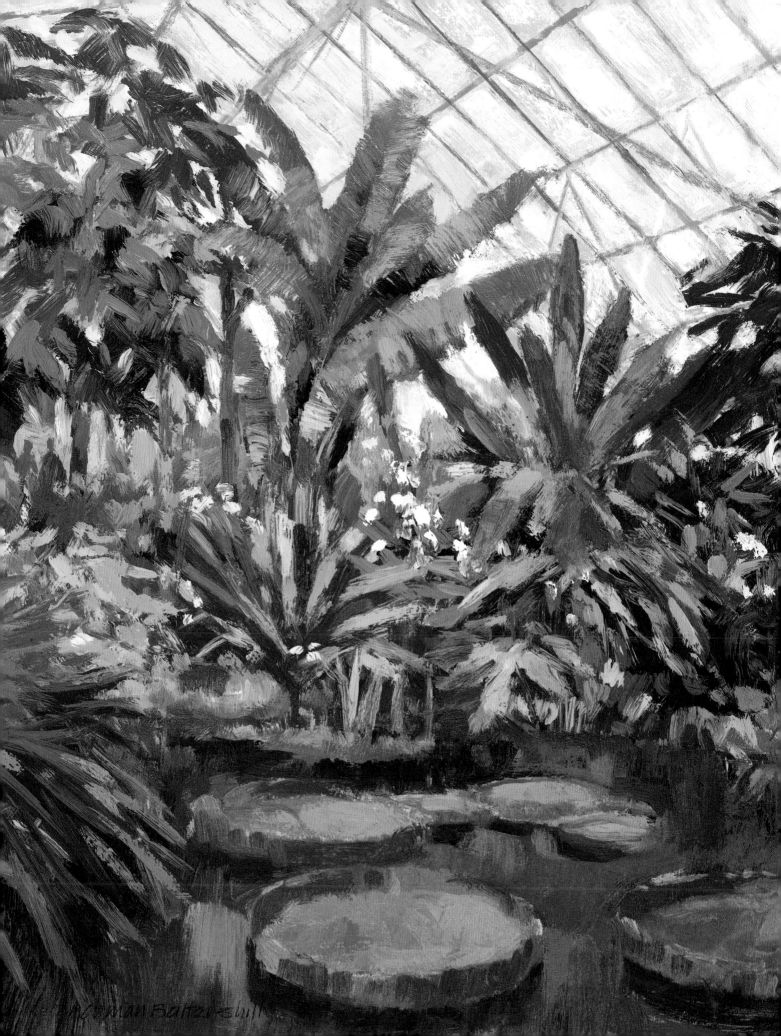

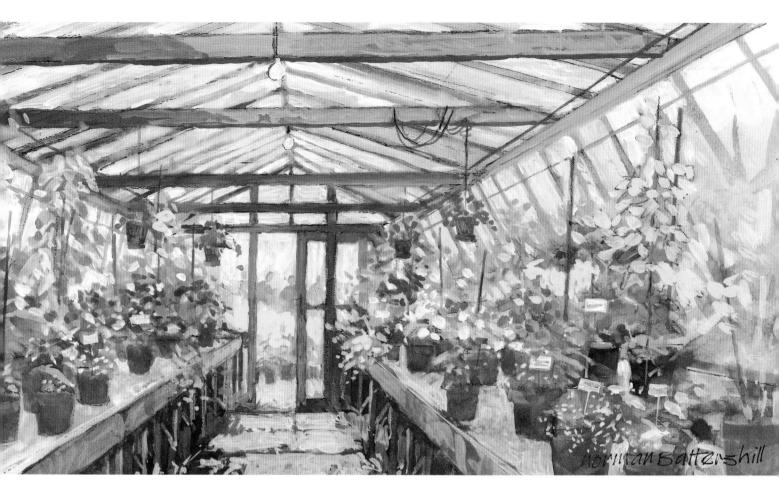

GLASSHOUSE INTERIOR.
Gouache on cartridge paper,
152 × 267 mm (6 × 10½ in.)

Sometimes, by cropping a painting, the composition becomes stronger and more interesting. Degas and Sickert used this technique for many of their paintings.

I had originally selected a viewpoint much further back for this glasshouse picture, but when I had finished the painting, I realized that the emphasis was on the perspective of the benches, which I did not want. The main interest of the subject is the roof structure and the door,

so I masked off the bottom of the painting with white paper to see what the difference would be. By chopping off about 75 mm (3 in.) the composition was greatly improved, and the narrow format made the painting much more interesting.

I did a careful drawing of this subject to get the perspective to look right, but when I came to the painting stage I did not keep too rigidly to the drawing. I used watercolour mixed with poster white, which has the same effect as gouache, and the translucency suited the kind of atmosphere that I wished to

convey. The Winsor & Newton watercolours that I used were French ultramarine, cadmium red, yellow ochre, cadmium lemon, burnt sienna, indigo and poster white.

GLASSHOUSE INTERIOR.
Line and wash (charcoal pencil and watercolour) on smooth card, 229 × 114 mm (9 × 4½ in.)

This watercolour is of a small part of the same glasshouse illustrated on page 95. In just this one area there were any amount of subjects from which to choose. I liked the stack of boxes in the foreground. Although this is the dominant feature of the painting, the composition is counterbalanced by the scaffolding and angle of the roof.

I made this watercolour transparent and direct to make full use of the brilliant white card. When the painting was thoroughly dry, I used a soft charcoal pencil to strengthen the drawing. The colours that I used were Payne's gray, cadmium yellow, light red, raw sienna, French ultramarine and viridian.

Remember that charcoal and conté pencil drawings must be fixed before watercolour is added, or the marks will smudge. For larger line-and-wash drawings, I often use a piece of charcoal stick for line and tone, and fix it with aerosol fixative.

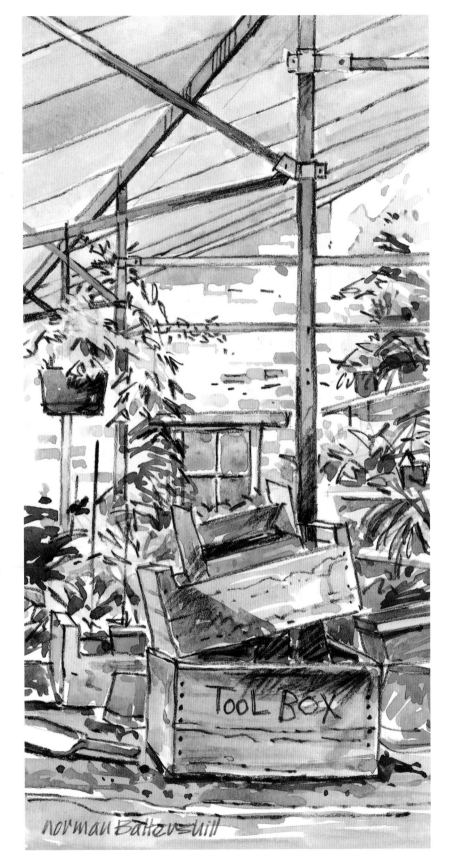

PALM HOUSE, KEW GARDENS.
Acrylic on blue-green pastel paper, reproduced actual size

When I was a young boy I lived within walking distance of Kew Gardens, and have cherished memories of being taken there by my mother and father on many Sunday afternoons. I remember my first impression of the enormous Victorian palm house, and the illusion of being transported into a strange tropical land. We explored the peaceful, beautiful gardens and walked by the River Thames. Little did I realize that years later as a young army volunteer I would be stationed a few miles up river at Hurst Park.

After one hundred and forty years of heat and condensation, the palm house was finally declared unsafe. In 1984 the mammoth task of dismantling and reconstruction began. Using the original 1844 specification and many of the existing materials, the work was finally completed in 1989.

Today, the curvilinear structure of the palm house remains the Victorian centrepiece of the Royal Botanic Gardens at Kew. To emphasize the scale of the jelly-mould structure, I selected a close-up view of the centre section and included some figures. The acrylic colours that I used were French ultramarine, cadmium yellow, cadmium red, burnt umber, raw sienna and titanium white.

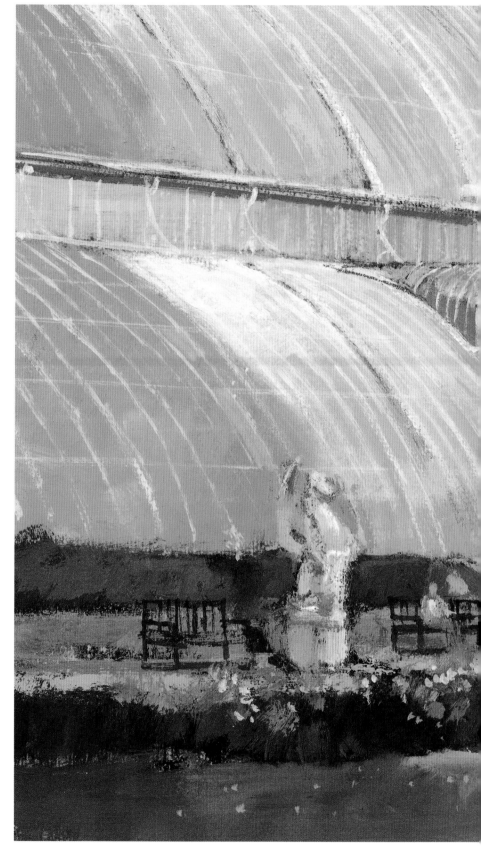

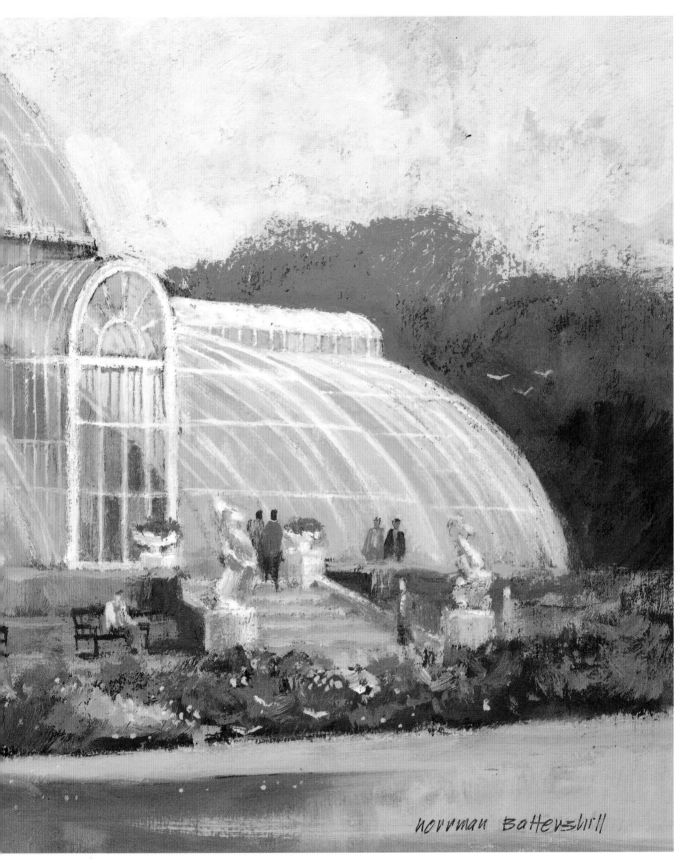

norrman Battershill

TREES

Trees are an essential part of the landscape and add beauty and interest to even the smallest of gardens. I have the greatest affection for trees and have come to regard them as friends. Most of my garden paintings include trees. Their strong shapes counterbalance horizontals and angles in a composition, and give life and interest to a painting.

The best way to paint trees well is to draw them, and this can only successfully be achieved by drawing outdoors. Begin your study when the leaves have fallen and you can easily see the graceful flow of trunk and branch. Make your drawing flow too. Copying from a photograph is not the same as painting outdoors, as a photograph may flatten shadows with a subsequent loss of form. The camera is better used for recording the structure of bare trees during the winter months.

A sketchbook of studies is the surest way to understand the character of trees. Charcoal drawing heightened with white pastel on neutral-tinted pastel paper makes an exciting combination for dramatic contrast or soft atmospheric effects.

A mass of leaves may seem confusing at first, but, if you observe carefully, you will see that the mass is made up of separate groups of leaves. The sense of a tree's energy and growth is better achieved by the simplification and elimination of unnecessary detail. If you find it difficult to stop fussing, put away all your small brushes and use just one large brush. The result will be lively and more likely to capture the spirit of the subject.

It isn't necessary to be able to identify every species, but it is important to be aware of the difference in shape and the texture of leaf mass. The silhouette of a tree identifies its species, and a great deal can be learned just by studying the characteristic outline and making simple silhouette sketches.

An interesting project is to paint a series of pictures of a fruit tree as it changes through all seasons, from winter to spring blossom and the bearing of mellow fruitfulness. Including an effect of weather adds further interest and atmosphere to a painting.

TREES IN THE LANDSCAPE.
Charcoal on cartridge paper,
reproduced actual size

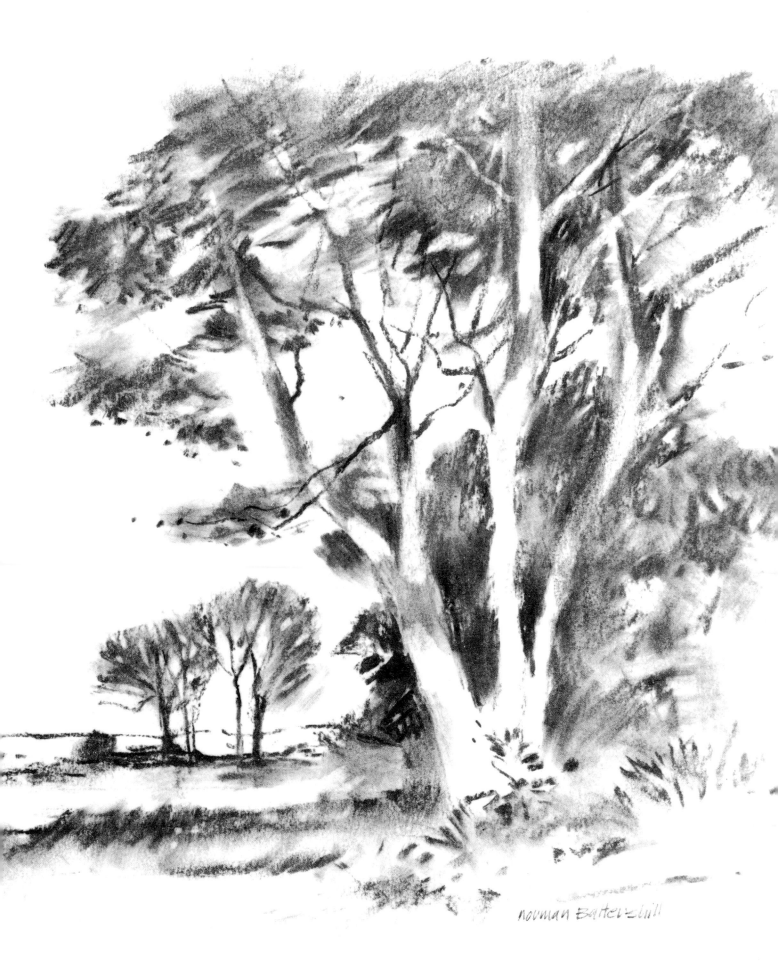

norman Batterhill

Trees in a painting must look as if they are growing out of the ground, not stuck on top of it without any roots. Observe the way in which the branches grow out from each other: each branch sends out another branch, which is smaller in thickness. From this branch are further smaller extensions, and so on. A piece of twig demonstrates the same subtle change in thickness of growth.

The elementary shape of a tree may be considered as either a cone or a ball. Side lighting defines the form of foliage mass and overall texture and may be used for dramatic effects in painting. The effect of sunlight and shadow on trees is often momentary, and the quickest way to capture it on paper is to use charcoal, conté or soft pencil.

Your sketchbook studies will form an invaluable source of reference for future studio paintings. The ability to paint trees will contribute a great deal to the success of your painting of all subjects.

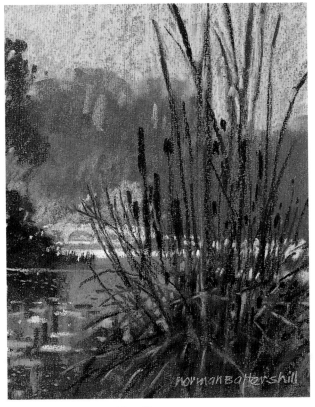

EARLY MORNING *(detail).*
Pastel on grey Tiziano pastel paper.

Simplified tree shapes such as those shown in this detail can be very effective – the dark green foliage is suggested but left undefined. The full painting can be found on pages 50–1.

(Opposite) TREES.
Watercolour on grey pastel paper, 305 × 231 mm (12 × 9 in.)

This watercolour shows part of the garden of a stately home, where specimen trees add interest to the tranquil setting. A horizontal shape would have included more of the garden, but I chose a vertical format to emphasize the height of the slender trunks. Making several rough sketches before starting to paint is a good idea for determining proportion and composition. As in this case, a small part of a scene may have more interest but still retain the essence of the subject.

I chose a grey pastel paper for this picture, and used its warm middle tone as a base from which to start. This also enabled me to establish the darker tones first. I mixed Payne's gray and a touch of cadmium red for these. Working from dark to light on a neutral-tinted paper is a technique favoured by many artists, as harmony of colour is ensured with transparent washes of pure watercolour on a warm ground. For the very light tones in the painting, I added a touch of white. Excepting the sky and the flowers, the rest of the painting was pure watercolour.

When I use tinted paper I draw in the composition with a white conté pencil. This has the advantage of being more visible than a lead pencil, and, if applied lightly, the mark is easily erased. The watercolours that I used were French ultramarine, cadmium yellow, Payne's gray, burnt sienna and raw sienna.

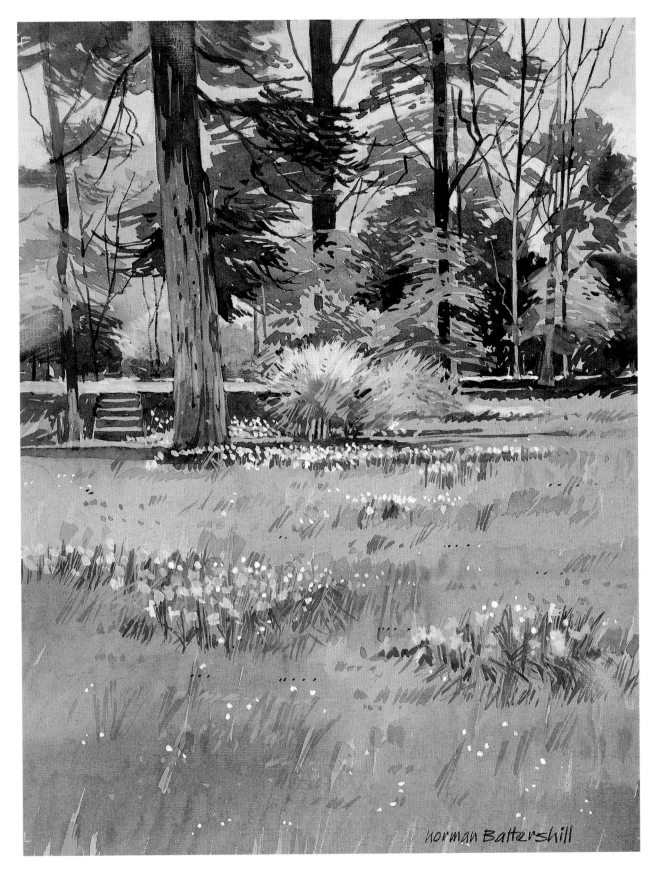

norman Battershill

WOODLAND.
Crayon on off-white pastel paper,
reproduced actual size

I seldom use crayon, but this book would be incomplete without including an example of this increasingly popular medium. I did this sketch in a woodland setting in a Dorset garden. The drawing was direct without any preliminary laying in.

Building up a drawing is slow and painstaking, but the finished effect warrants the time taken. After working on the sketch for a while I found the bright, instant colours quite exhilarating, and, not being at all used to working with this medium, I was very satisfied with the result.

There are more advanced techniques for drawing with coloured pencils and crayons, but this illustration is an example of a straightforward application of this versatile and very rewarding medium.

(Opposite page) STUDIES.
8B pencil on paper,
231 × 178 mm (9 × 7 in.)

A random selection of small pieces from only three of the trees in the garden provided fascinating material for these pencil drawings. Whenever I make detail studies I am constantly amazed at the wonderful rhythm in nature. Linear drawing is an exploration of delight, and teaches us to see the structure

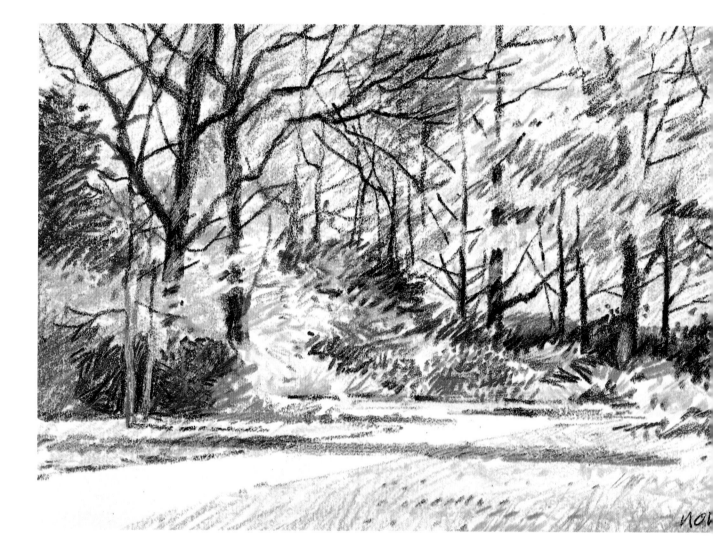

of things. I have never been bored with this kind of detail drawing and always learn something new and interesting from it.

At the bottom of my page of sketches are two drawings larger than life-size, drawn with the aid of a magnifying glass. The drawing on the left is a section through a cherry from the sprig drawing above it. The opposing outer curves and the middle shapes create a wonderful abstract pattern. I can visualize the section of the cherry as a large painting that I might try later on.

Sycamore fruit gyrating to the ground like small helicopters is a unique sight in the autumn. My drawing on the top right of the page shows a cluster of seeds before they had separated from the twig. The wings were the colour of deep raw sienna, and some fruits were still green, while others had changed to a lovely autumnal copper colour.

As I was drawing the enlarged detail of the sycamore fruit (bottom right), I felt a thrill of excitement when I discovered that the dried wings looked like a beautiful line of slender winter trees in miniature. Nature has endless secrets to delight us.

(Below) AUTUMN TREES.
*Pastel on neutral-tinted pastel
paper, 216 × 445 mm
(8½ × 17½ in.)*

The wonderful russet colours of autumn present a challenge to the artist trying to capture it all in paint. Painting a bright autumnal picture is not very difficult, but creating an overall effect of harmony is a different matter altogether. Using pastel on tinted paper is one of the best methods of achieving harmony. The range of beautiful colours is extensive, and application is instant and a visual delight.

For my subject I chose a woodland setting in a large garden open to the public. I was spoiled for viewpoints, and could have found many more subjects just by turning around on one spot, but I selected this one because the path leads into the picture and enhances the sense of depth. I left the neutral grey of the pastel paper showing through here and there.

To link one side of the painting to the other I introduced the same colours. The shadows across the path also join up the sides. Black pastel is very assertive and has to be used with discretion. I used it here as a contrast against the bright, sunny colours. Figures in the distance add to the sense of depth and also give scale to the height of the trees. When you are including trees in a painting, this is an important element to remember. Using such lovely intense colours gave me the greatest pleasure in producing this pastel painting.

(Opposite) EVENING.
*Charcoal on smooth white card,
165 × 231 mm (6½ × 9 in.)*

I have included this charcoal drawing to illustrate how trees add mood and atmosphere to a subject. It is also an example of the versatility of the expressive medium of charcoal. A full tonal sketch can be worked out as a prelude to painting. My illustration has a full range of tone values, but a simplified version would be just as useful. Before I began the drawing I applied charcoal all over the area and lightly rubbed it in with kitchen tissue. A kneaded

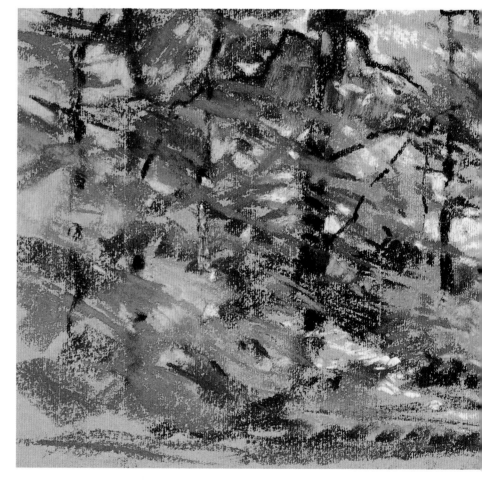

putty eraser lifted out the lighter tones, and a paper tissue softened the middle tones. The technique of lifting out the lightest parts is very exciting because you are never certain what the effect will be. To achieve the darkest tones, I fixed the drawing when it neared completion, then added the darks and fixed it again.

Charcoal is ideal for any subject, and is particularly versatile for drawing trees, either as a close-up study or in a setting, as in my illustration here.

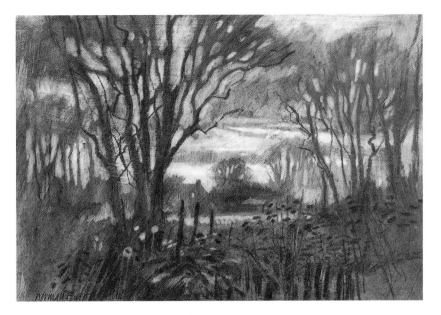

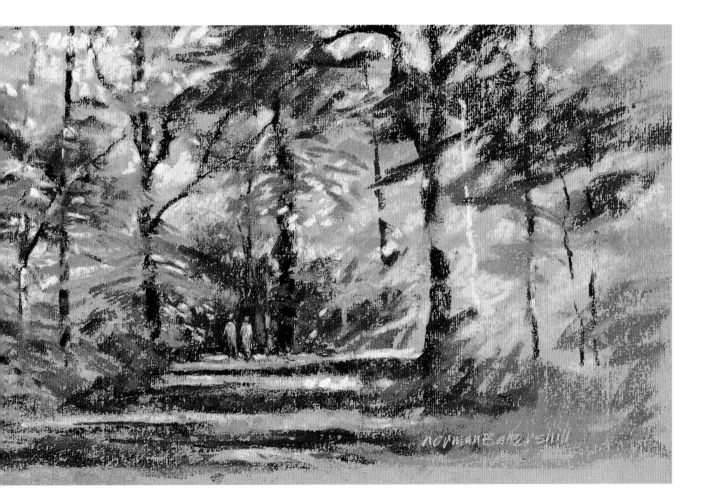

SUMMER TREES.
Acrylic on thin white card,
145 × 182 mm (5¾ × 7¼ in.)

This acrylic sketch is an example of 'cutting out' tree shapes by painting the sky last.

I began the painting with a transparent wash of Payne's gray and French ultramarine. When the colour had dried, I roughed in the general composition with French ultramarine mixed with cadmium red, but no white.

Next, I blocked in the silhouette of the distant tree with a mixture of cadmium red and French ultramarine.

I used the same colour for the middle-distance trees, but also added cadmium yellow medium.

The nearest shrubbery and trees are French ultramarine and cadmium yellow medium with a touch of cadmium red.

When the colour was dry, I created the silhouetted trees by cutting round with the sky colour of French ultramarine, white and a touch of cadmium red. I used the sky colour to pick out the shape of the trunks and gaps in the foliage with a smaller brush. The sky between gaps is always slightly darker in tone. Once I had established

the trunks I could add their branches, and, when the sky background had dried, I put in further branches. This technique of painting trees is exciting because shapes emerge as silhouettes.

I painted this picture direct, and completed it in one session. There were many more branches on the foreground tree, but I deleted some of them to simplify the subject. You need not confine your tree studies to gardens. Including them in a landscape painting or in subjects such as this will increase your ability to paint them well.

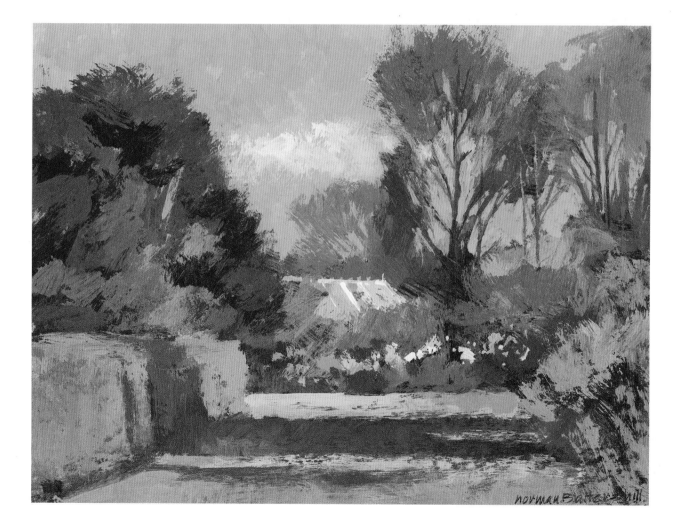

DECEMBER SNOW.
Acrylic on smooth white card,
165 × 242 mm (6½ × 9½ in.)

This is an imaginary subject that I painted in the studio from outdoor sketches, and it illustrates how a blanket of snow can completely change the appearance of a familiar scene. Trees become the dominant features, and we can easily define the beautiful linear structure of trunk, branch and twig. The evergreen pine trees on the left in my painting make contrasting bold masses.

The old apple tree is in a neighbour's garden and has been the subject for several of my paintings. I used a well-worn oil-colour brush to try to capture its rugged line. I simplified the tree by leaving out a mass of twigs as, had I included them, I think the character would have been lost. There were also low branches spreading near the ground, but I wanted to emphasize the verticals so I left these out as well.

The acrylic colours that I used were French ultramarine, cadmium yellow, cadmium red, burnt sienna and white.

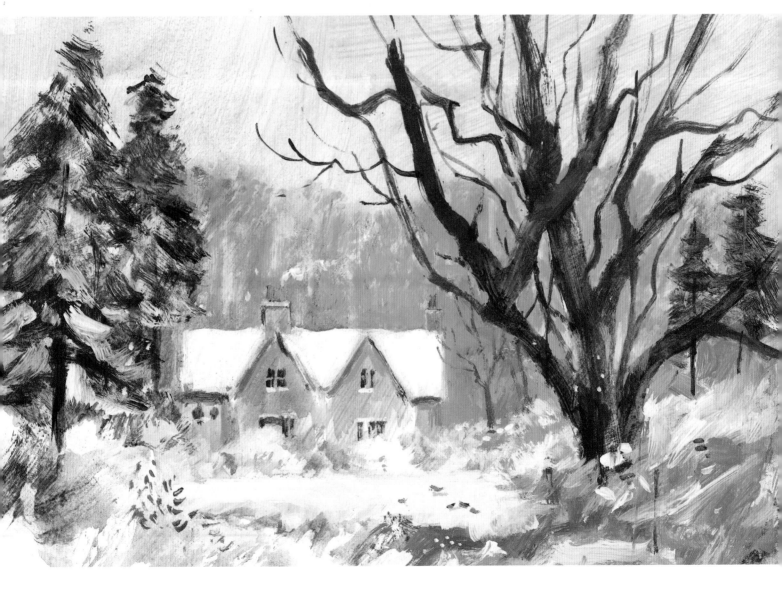

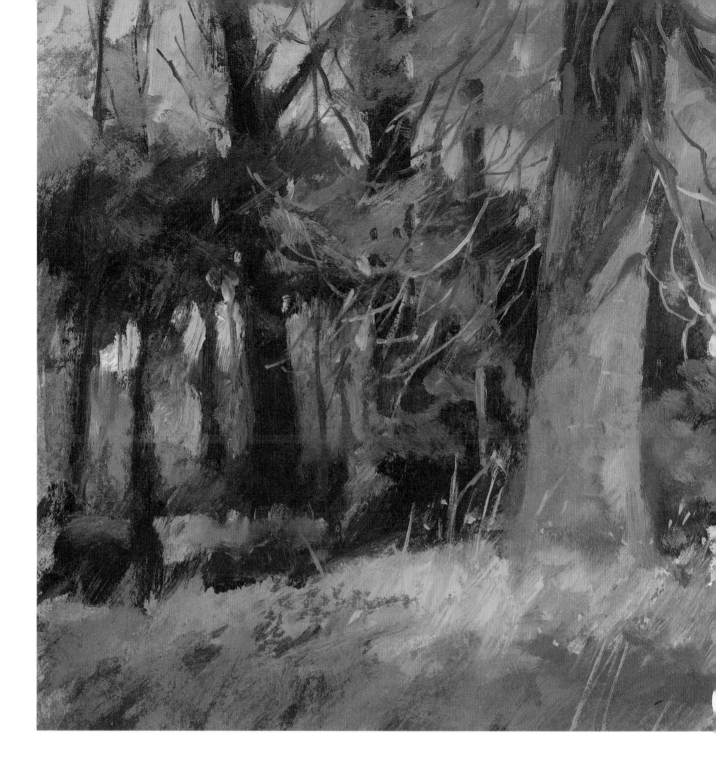

AUTUMN LIGHT.
Oil on acrylic-primed paper,
210 × 270 mm (8¼ × 10¾ in.)

I am very fortunate in that, just a few yards down our lane, there is a magnificent wood containing a variety of species. I have spent many pleasant hours painting there or just walking and observing, enjoying the stillness. I endeavoured to capture the power and strength of this group of trees in this small oil painting.

If emphasis is given to too many trees in a painting, interest cannot come to rest.

For my tree study I selected the nearest one as the focal point. I counterbalanced the sunlit part of the trunk with silhouettes in the background, which also creates an effect of depth and atmosphere.

The oil colours that I used were French ultramarine,

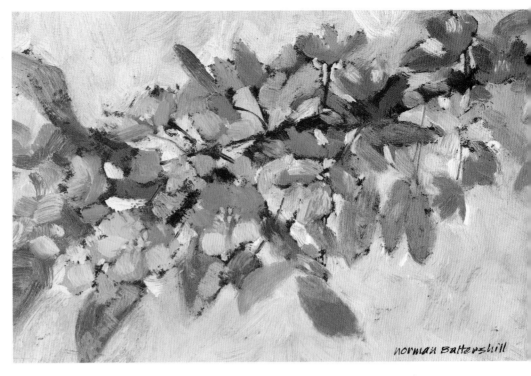

CRAB-APPLE BLOSSOM.
Oil on acrylic-primed paper,
128 × 180 mm (5 × 7¼ in.)

Crab-apple blossom on spring-flowering trees makes a delightful study to paint. The pink flowers are a welcome prelude to the expectation of summer, and provide an opportunity to further our understanding of trees. For practical reasons my oil-colour study was painted in the studio, and before I began to paint I turned the spray of blossom over several times to decide on the most interesting angle.

I painted the blossom direct without any preliminary drawing in, and ignored small bits of detail. For bold brushwork I kept to one size of brush, a Winsor & Newton no. 4 hog, and only used a small brush for the pale yellow stamens. The rosy undersides of the petals give the crab-apple blossom a unique beauty, and for this darker colour I added a touch of burnt sienna to cadmium red. The pale pink is a mixture of cadmium red, cadmium lemon and white.

I painted the background last, adding a touch of all the four colours on my palette – French ultramarine, cadmium red, cadmium yellow and burnt sienna – to titanium white.

cadmium red, burnt sienna, cadmium yellow, cobalt blue, cadmium lemon and titanium white. I used a no. 4 long, flat oil-colour brush for most of the painting, and a synthetic no. 4 brush for smaller work. This simple subject of trees gave me the greatest pleasure to paint.

PAINTING FLOWERS AND GARDENS INDOORS

The view through an open door or window into the garden can make an interesting composition of a frame within a picture frame. Relating the inside to the outside to achieve harmony of the whole is important, and there are several ways in which to accomplish this.

When you look through your window at the view beyond, there are sure to be similarities of verticals, angles and horizontals. Harmonizing the outside with the inside may also be achieved by the 'tie-in' of colour. For example, the colours of the flowers in the garden may be added to the colours of the interior. Closely related tones also have the effect of unifying the two separate planes.

Painting a view of a garden from indoors provides the opportunity of seeing it from interesting levels. A viewpoint looking down from an upstairs window, for instance, has many possibilities for a series of paintings of your own and neighbouring gardens. Taking a viewpoint such as this can create perspective problems, but making preliminary sketches to determine eye level and vanishing points will help to solve any problems before you start painting. In the comfort of being indoors you can also paint the inclement weather outside.

The great advantage of painting a view from indoors is that you are able to paint over a long period with greater concentration. You also have the opportunity to paint a more ambitious subject on a larger scale.

Time and the weather are not always on our side when painting flowers in the garden, whereas setting up an arrangement of flowers indoors gives the advantage of being able to work in controlled-light conditions. My studio has ample natural light, so I can work for a full day without the necessity of artificial light.

Wildflowers are one of my favourite subjects, and painting them in the studio is often more practical than outdoors. Although some common wildflowers seem very plentiful, such as deadnettle, campion, buttercups, wild garlic, daisies and dandelions, etc., for the sake of conservation, I pick only a few. To give the impression of plentiful flowers in my painting I often move some of them around and paint another angle of the same flower. Flowerheads droop more quickly than leaves, so I establish their colour, tone and form as quickly as possible, and I then have a colour key for the final stages of the painting.

Choosing a suitable background colour for a still life is sometimes a problem, and requires

SUMMER MORNING.
Oil on canvas, 231 × 178 mm
(9 × 7 in.)

The flat light of an early morning sky gave me the opportunity for this oil painting of a garden view. I deleted all the smaller details in the flower border to achieve simplicity of shapes. Fortunately the light was constant, so I did not have the problem of changing shadows. My painting is really just a loose sketch, but has the possibility for a much bigger studio painting.

It is invariably necessary to change some aspects of a subject. Here, to achieve harmony, I altered the background of green trees to purple. This had the effect of creating a sense of depth, and adding to the atmosphere. I did not give the curtain defined folds, but softened it to add to the effect of light. Fitting the sky to the landscape is often more successful than painting the sky first. As I was not sure of the tone and colour of the sky, I left it until last.

The oil colours that I used for this painting were French ultramarine, alizarin crimson, cadmium red, cadmium lemon, burnt sienna, raw sienna and titanium white.

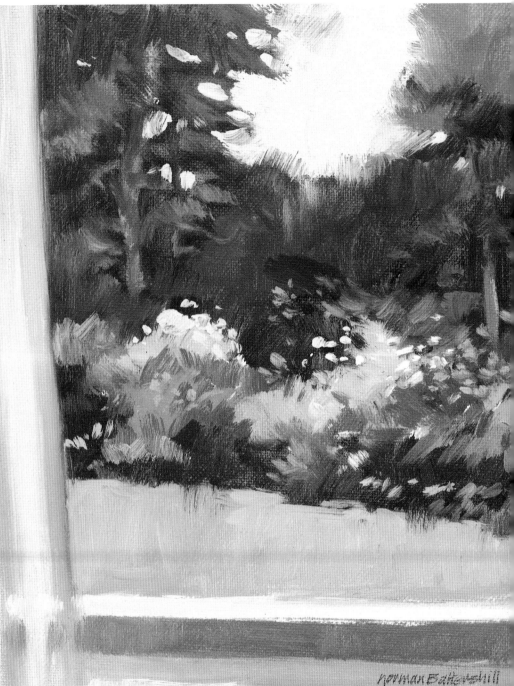

115

careful consideration. One accepted method is to mix together all the colours that you have used for the still life, with the idea that the result will be a neutral grey. It does not always work like this, however, and the resultant mix can turn out to be muddy and lifeless. A better method is to make a grey and then to add touches of the flower colours within the painting to achieve harmony.

Modern commercial growers have perfected techniques to induce plants to flower throughout the year, so that it is possible to paint flowers indoors at any time. One of the most popular varieties is known as the florist's chrysanthemum. These cheerful flowers have an extensive range of colour, and are a joy to paint either in their pots or arranged with other flowers.

A group of flowers in a water-filled glass jar is one of my favourite subjects. The effect of light in the jar makes a wonderful contrast to the opaque colours of the flowers, and it is one of the most exciting subjects to paint.

(Left) FLOWER STUDY.
Watercolour on smooth white card,
231 × 178 mm (9 × 7 in.)

Making careful studies is an endless source of enjoyment and discovery, and I never cease to be thrilled at learning the secrets of nature. During the winter months we can continue the pleasure of painting and drawing flowers by working in the studio. The watercolour on the left is a studio painting of campanula.

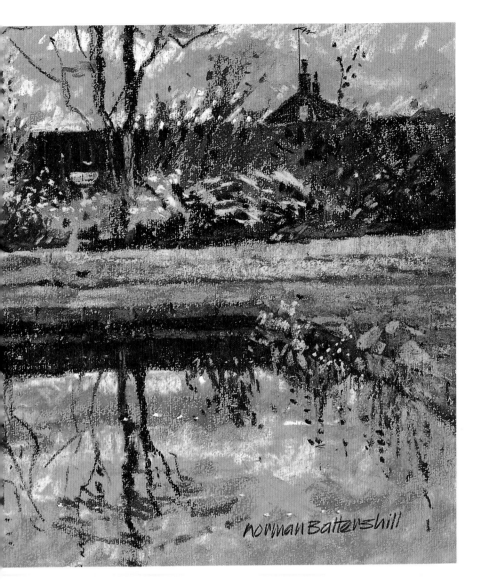

AFTER THE RAIN.
Pastel on blue pastel paper,
254 × 406 mm (10 × 16 in.)

Changing aspects of weather present a wonderful opportunity to capture an atmospheric effect. When it has rained, all the colours and tones in the garden are enriched as if everything has been given a coat of bright varnish. I tried to capture the effect in this view of a garden looking out from indoors.

The sky was full of cumulus clouds with the sun catching the tops. Although it looked dramatic and beautiful, my subject was really about the effect of light on the garden, so I decided not to emphasize the sky too much – the narrow strip makes an interesting composition. Verticals are important here as a counterbalance to the strong horizontals, as without these the subject would be unbalanced.

I began the pastel by roughing it in with a piece of charcoal. The advantage of this method is that the darks are quickly established but easily erased if necessary. With a low-key painting it is tempting to overstate the lighter parts and lose tonal harmony. I could easily have made this error by making the irises and distant flowers too bright. Water is always slightly darker than the sky, so I was careful to get the tones of the reflections right.

The bold, sweeping curve of the leaves and the delicate flowers fascinated me. I took off the perished petals to reveal the beautiful form hidden underneath.

For this watercolour I first made a very light pencil drawing with a 2B pencil. Smooth white card will not tolerate rubbing out, so my drawing had to be fairly accurate first time. As I did not want a botanical-style illustration, I left out a lot of detail and emphasized only the big shapes. The character of a plant is defined by its manner of growth and form, and these were the elements that I endeavoured to illustrate in my painting.

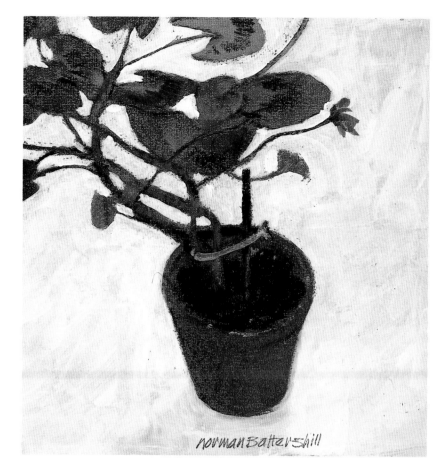

norman Battershill

PATTERNS.
*Acrylic on board, 686 × 610 mm
(27 × 24 in.)*

Here I have chosen a small part
of a large painting to illustrate
the way in which patterns form
an important aspect of flower
painting. The geranium leaves
create big, rhythmic shapes, in
contrast to the slender stems.
The spaces in between also
form a variety of delightful
patterns.

The small black-and-white
drawings below clearly show
the value of observing inner
and outer shapes. These
exercises are never boring and
do much to further our powers
of observation. Seeing, and not
just looking, is the key to
remember in all flower
painting.

GARDEN STEPS.
Oil on acrylic-primed Bockingford watercolour paper, 203 × 254 mm (8 × 10 in.)

A view from indoors looking down garden steps creates an interesting viewpoint. My oil sketch is an example. I had to simplify the mass of foliage and flowers to achieve a broad impression of the subject. Although space in this tiny garden was restricted, I created depth by keeping broader brushstrokes in the foreground, and also narrowed the path a little as it recedes. The diagonal shadows on the path add further recession.

Big ellipses on the foreground flowerpots create the impression of looking down. Verticals of lupins on the left are critical as a counterbalance to the horizontals of the path, and also add to the illusion of looking down. This painting is just a rough sketch, made as a simple example of a viewpoint from indoors. From a first-floor window the perspective would be very acute.

The oil colours that I used were cobalt blue and alizarin crimson for the lupins, and, for the rest of the painting, French ultramarine, cadmium red, cadmium yellow, burnt sienna and titanium white.

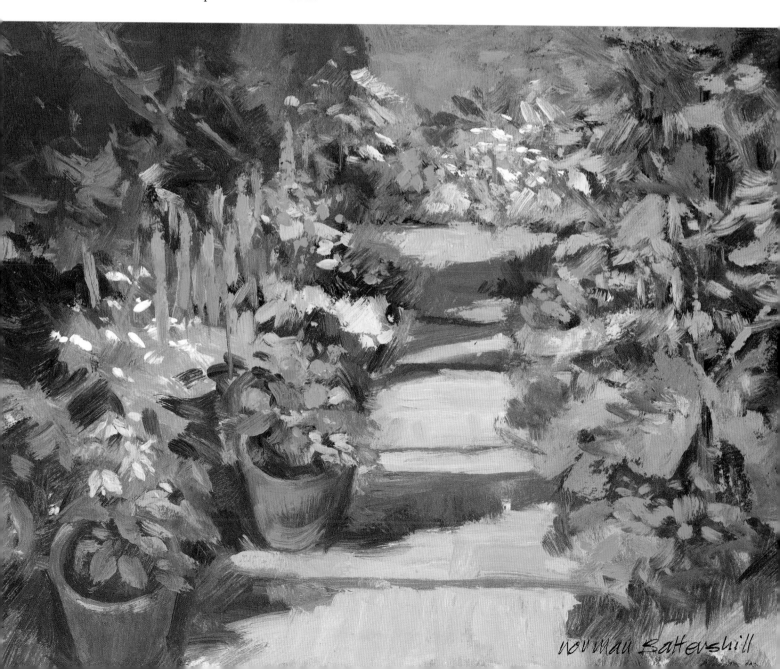

norman Battershill

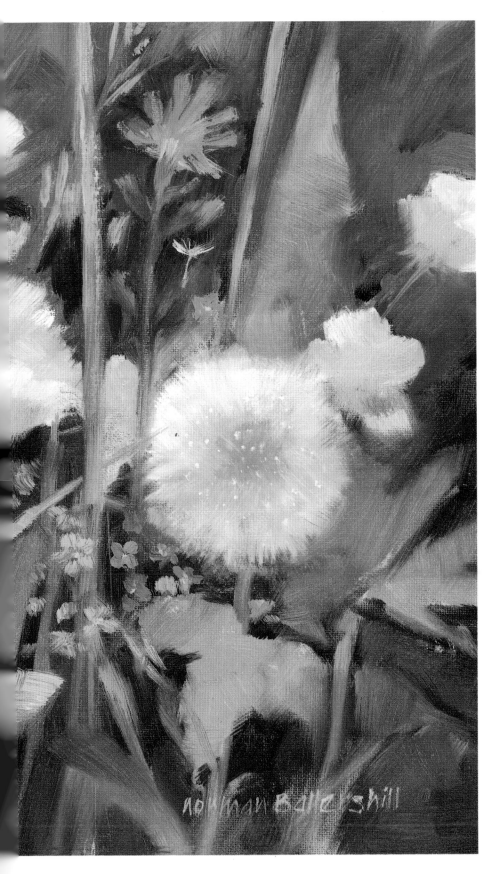

WILDFLOWERS.
*Oil on canvas, 231 × 330 mm
(9 × 13 in.)*

Painting wildflowers in the studio brings a breath of the countryside indoors. This studio painting shows a collection of red campion, dandelions, buttercups, deadnettle and forget-me-nots. Instead of cramming the flowers into one pot, I arranged them in separate jars on my painting table.

The dandelion globe of seeds attached to a parachute of tiny hairs is very delicate, so I kept the globe completely separate. A method of keeping it all intact is to spray it gently with hair lacquer. One of the wonders of nature is the way in which the seed is dispersed on its tiny parachute. I have shown this action to the right of my painting. Trying to capture the downy effect of the globe of hairs is difficult; working wet-into-wet on the white priming with thinned paint is the method that I use. Surrounding areas of opaque colour emphasize the translucency of the beautiful downy globe.

I used the collection of flowers in separate jars to try to create an impression of wildflowers outdoors in their natural habitat. I am fortunate to live in the heart of the countryside, so I can observe how these summer flowers grow in the hedgerows, and use the information for studio work.

121

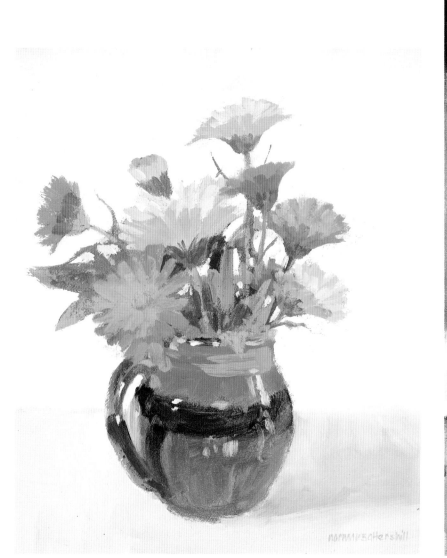

(*Above*) MARIGOLDS.
*Acrylic on board, 406 × 254 mm
(16 × 10 in.)*

The cheerful colour of
marigolds makes a lively flower
study, and these flowers were a
joy to paint. My studio has top
light as well as side windows,
so the effect of light defined the

form with good contrasts.
Before starting to paint, I
turned the group round several
times to find a balanced
composition. A haphazard
arrangement of flowers looks
more natural than a formal
grouping, so I did not try to
improve it by changing things.
The handle of the brown jug

leads into the subject and echoes
the curve of the flower shapes.

The colours that I used were
burnt sienna, burnt umber, raw
sienna, cadmium red, cadmium
orange, cadmium yellow
medium, French ultramarine
and white.

This painting was on display
in the gallery with the jug and

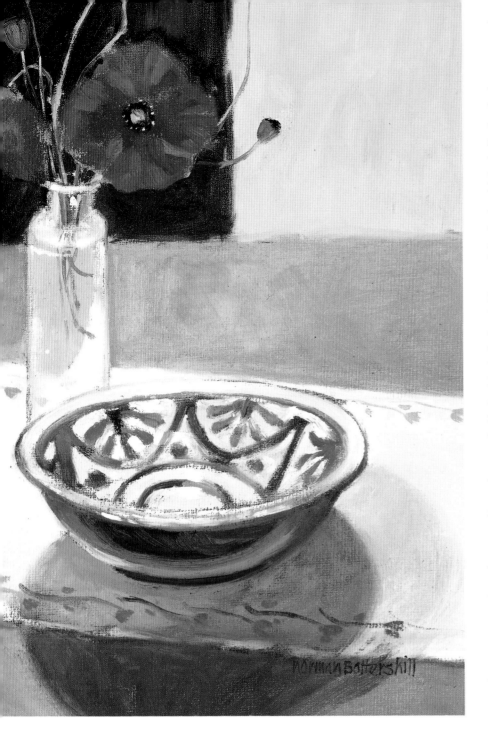

the gentle pattern repeats the flower motif. I have a collection of old glass bottles, and this one has a slender shape to contrast with the bold pattern of the bowl. The vertical is an important counterbalance to the ellipse and the various angles. I added a repeat vertical in the background.

Painting water in a glass fascinates me. It is very tempting to over-do the detail and can result in losing the effect, so I always simplify what I see into main shapes. Including water in a glass in a still-life composition adds further interest and creates an effect of light.

This group was arranged on a big old wooden drawing-board. As my painting progressed, the colour of the board did not harmonize with my colour scheme, so, when the paint was dry, I scumbled a blue-grey over that part of the painting. This neutral colour is cool, and counterbalances the red of the poppies.

Unless objects overlap in a still-life group, the composition loses unity and interest is diverted. Here, the bowl overlaps the bottle and cast shadows link the base with the paper strip. I don't think that I should have placed the bowl so near the top edge of the paper, as a little more space between the two would have been better.

The colours that I used were French ultramarine, cadmium red, raw sienna, burnt sienna, cadmium yellow and titanium white.

marigolds on a table beneath it. The painting was bought, and the jug and marigolds given to the delighted purchaser.

POPPIES AND A BLUE BOWL.
Oil on primed hardboard (Masonite), 305 × 330 mm (12 × 13 in.)

A simple arrangement of just a few pieces makes an interesting and strong composition here. The strip of kitchen tissue picks up the blue of the bowl and

FOXGLOVES AND BUTTERCUPS.
Oil on canvas, 610 × 507 mm (24 × 20 in.)

CONCLUSION

ainting in a much-loved garden bright with summer flowers is one of the greatest joys that an artist can have. In my quest for material for this book, I have had the most enjoyable opportunity of visiting a great many different gardens.

It has not been at all difficult to find more than enough fascinating subjects. The problem has been in selecting just a few from the numerous alternatives to illustrate the specific subjects covered in the book.

I hope that the examples I have chosen will arouse your interest, and may inspire you to look for the wider aspects of painting gardens.

Norman Battershill

PUBLICATIONS LISTING GARDENS TO VISIT

English Private Gardens
Judy Johnson and Susan Berry
(published by Collins and Brown, 1991)

THE GARDEN CLUB OF AMERICA
598 Madison Avenue
New York NY10022
(*A national organization made up of member clubs dedicated to the protection and conservation of the American environment*)

GARDENS OF ENGLAND AND WALES
The National Gardens Scheme
Hatchlands Park
East Clandon
Guildford
Surry GU4 7RT
(*Publication listing more than 2,600 privately owned gardens open only on specific dates*)

GARDEN TOURS
Premier Suite
Central Business Exchange
Central Milton Keynes MK9 2EA
(*Brochure listing 50 tours visiting over 500 gardens in the U.K. and Europe*)

The Good Gardens Guide
Edited by Graham Rose and Peter King
(published by Barrie and Jenkins)
(*Includes over 1,000 gardens in Great Britain and Ireland*)

Hudson's Historic House and Garden Directory
(published annually by Norman Hudson & Co., Banbury, Oxon)

HISTORIC HOUSES, CASTLES AND GARDENS IN GREAT BRITAIN AND IRELAND
Reed Information Services Ltd
Windsor Court
East Grinstead House
East Grinstead
West Sussex RH19 1XA
(*Published annually in February. Lists details of over 1,300 properties and gardens open to the public*)

THE HISTORIC IRISH TOURIST HOUSES AND GARDENS ASSOCIATION
c/o Dalkey Travel
3A Castle Street
Dalkey
Co. Dublin
(*Illustrated booklet with information on over 50 properties*)

THE NATIONAL TRUST FOR SCOTLAND HANDBOOK
5 Charlotte Square
Edinburgh EH2 4DU
(*Publication lists over 100 properties, including 22 major Scottish gardens*)

THE NATIONAL TRUST GARDENS HANDBOOK
The National Trust
36 Queen Anne's Gate
London SW1H 9AS
(*Publication listing a wide variety of gardens in the Trust's care in England, Wales and Northern Ireland*)

THE ROYAL HORTICULTURAL SOCIETY
80 Vincent Square
London SW1P 2PE
(Members' monthly journal featuring informative aspects of gardening. Lists gardens to visit)

SCOTLAND'S GARDEN SCHEME
31 Castle Terrace
Edinburgh EH1 2EL
(Handbook and brochure with details of openings and coach tours)

THE ULSTER GARDENS SCHEME
The Public Affairs Manager
The National Trust
Rowallane,
Saintfield
Co. Down BT24 7LH
(Lists of private gardens open to the public)

FURTHER INFORMATION ON GARDENS

Books on gardens

There are books on practically every aspect of gardens, and they are too numerous to list here. Most bookshops stock a selection, and many garden centres also have a book section.

Finding garden centres and gardens

Yellow Pages directories are compiled and published by British Telecommunications plc and list garden centres in various areas. The directories can normally be found in the reference section of public libraries and some main post offices.

Local and national newspapers and county publications often carry advertisements by garden centres.

The Automobile Association and the Royal Automobile Club are able to supply information on the location of gardens open to the public.

Tourist-information centres

Some tourist-information offices have literature relating to gardens to visit.

Weekly and monthly English magazines with garden interest and information

Country Living
House and Garden
House Beautiful
Good Housekeeping
Ideal Home
Garden News

The Gardener
Gardener's World
Garden Answers
Practical Gardening
Amateur Gardening

Painting courses

The English Gardening School
Chelsea Physic Garden
66 Royal Hospital Road
London SW3 4HS
(Botanical and garden-painting courses)

The Artist and Leisure Painter magazines
The Artist Publishing Company Limited
Caxton House
63–65 High Street
Tenterden
Kent TN30 6BD
(Informative monthly art-instruction magazines. Botanical and flower-painting courses occasionally advertised)